A GLORIOUS FREEDOM

A GLORIOUS FREEDOM

OLDER WOMEN LEADING EXTRAORDINARY LIVES

LISA CONGDON

CHRONICLE BOOKS
SAN FRANCISCO

To all the late bloomers.

Library of Congress Cataloging-in-Publication Data

Names: Congdon, Lisa.
Title: A glorious freedom : older women leading extraordinary lives / by Lisa
 Congdon.
Description: San Francisco : Chronicle Books, [2017]
Identifiers: LCCN 2016039249 | ISBN 9781452156200 (alk. paper)
Subjects: LCSH: Women—Biography. | Self-realization in women. |
 Aging—Psychological aspects.
Classification: LCC HQ1123 .G59 2017 | DDC 305.4—dc23 LC record available at https://lccn.loc.gov/2016039249

Manufactured in China

10 9 8 7 6 5 4

Chronicle Books LLC
680 Second Street
San Francisco, California 94107
www.chroniclebooks.com

CONTENTS

INTRODUCTION
by Lisa Congdon

7

INTRODUCTION
by
Lisa Congdon

"Age has given me what I was looking for my entire life—it has given me me. It has provided time and experience and failures and triumphs and time-tested friends who have helped me step into the shape that was waiting for me. I fit into me now. I have an organic life, finally, not necessarily the one people imagined for me, or tried to get me to have. I have the life I longed for. I have become the woman I hardly dared imagine I would be."

—Anne Lamott

The book you are holding in your hands is a book about women. It is a book about women over the age of 40 who are thriving.

You might ask, *Why make this book? Why are the lives of older women worth celebrating?*

My own life's path is what piqued my interest in the topic. I am a self-described late bloomer. The year this book is published, I will be 49 years old. By profession, I am an artist, an illustrator, and a writer. I did not begin drawing or painting until I was 31 years old. I did not begin my illustration career until I was 40. I did not begin writing regularly until I was 42. I did not publish my first book until I was 44.

I did not get married until I was 45. I just published my seventh book. My eighth comes out next year.

Every year that passes, I become braver, stronger, and freer. Getting older has, for me, been an enormously gratifying and liberating process. I am a kinder person to others than I have ever been, and I also care far less than I ever have about what other people think of me. I am both more determined and harder working than I was when I was younger, but I also value experiencing joy in my life over my work ethic more than I ever have. I am both more secure and more vulnerable. Out of years of living with intense insecurity and

trepidation, the wisdom of age has taught me the importance of courage and that my own unique path is just that—my own unique path. Aging, as Anne Lamott so eloquently put it, has led me to myself.

In an effort to express my feelings on the topic, I wrote a short essay on getting older in 2014 and published it on my blog. That essay was quickly shared by thousands on the Internet, both through my blog and through social media channels. Although I have a decent social media following and a devoted audience of blog readers, I am not a celebrity or a full-time blogger, so the attention this essay garnered was rather phenomenal. I realized that if the topic of getting older and thriving was resonating so strongly with so many women, then I needed to explore it further.

And that is, of course, where the germ of this book sprouted. I had long admired some well-known late-blooming women and seen them as role models since I was in my 30s. I already had ideas of the women I wanted to include in this book. But I also used the power of social media to gather even more names and contacts. I began the process of making this book by reaching out to my Internet community (my social media followers and blog readers) with one basic request: help me find the women you know or admire who exemplify bold and adventurous aging—artists, writers, athletes, scientists, activists, thinkers, designers, and feminists over 40 who are embracing the positive aspects of getting older: the wisdom,

emotional resilience, work ethic and play ethic, insight, and sense of humor that come with age. I asked my followers to help me identify women who were late bloomers, women who hit the apex of their careers later in life or who made some bold move to live in interesting ways after the age of 40.

The response was astounding. I received emails from scores of men and women around the world with all flavor of submissions: long lists of women I should profile or interview, along with essay submissions from women about the process of aging, their relationship to aging, the struggles, the triumphs. The response to my call was, in fact, so astounding that I was literally overwhelmed with how to contain the potential for the book. I'd contracted with my publisher, Chronicle Books, to make a book that was 155 pages, and I was absolutely sure I'd have enough material to make a book five times that length!

I set out to cull together the best of everything I received—to research and write about women I admire, to contact real-life female heroines for interviews, and to sift through the endless essay submissions for the book to fit it into the format you are holding in your hands.

Historically and across cultural divides, women have been told to remain silent, to sit still, to hold back, not to shine. In addition, women have traditionally regarded their ability to please others—over following their own dreams and desires—as one of their greatest strengths.

Furthermore, for countless generations, women have been told that once they hit middle age, their opportunity for greatness has passed.

And so the resilience and courage demonstrated by women, and, in particular, the ever-growing population of older women, to challenge and redefine these notions is one of the most exciting things to observe in the world today. We live in a time when more and more women are beginning to live out loud, to follow their own desires and dreams, to be who they are, to live fully, to live a second life after their children leave home, or their partners are no longer with them, or their previous careers are no longer meaningful.

This book profiles many women who paved the way for us—women like Katherine Johnson, Louise Bourgeois, Julia Child, and others who were challenging notions of what it meant to be an "over-the-hill" woman long before today. Many of these women discovered hidden passions and talents much later in life or hit the most exciting and fruitful time of their careers as older women. They are, undeniably, role models for reimagining what our lives can be. The book also tells the stories of extraordinary women today who are reinventing what it means to be an older woman—women who are breaking through barriers, successfully completing athletic feats, and doing their best work in their 60s, 70s, and 80s.

When I first put out a call for suggestions for the book, I got a handful of emails and Internet comments from older women for whom aging was actually *not* enjoyable or interesting—the onset of health issues was no fun at all, and the death of loved ones was a regular part of their lives. These perspectives are real. And so my point here isn't to establish some sort of Pollyannaish portrayal of female aging. Things like bodily changes, shifts in the brain, and the experience of losing loved ones are very real (and often very painful) parts of growing older, and no one escapes them. However, I hope what we can see inside the stories in this book is the enormous potential for courage, perspective, spiritual growth, and humanity that often grow out of these struggles. My aim here is to provide hope to women who are aging (or fear aging) that, while the likelihood of ugly side effects grows ever larger, so too does our capacity for love, for compassion, for brave acts, for vulnerability, and for creativity.

And so here I go—*here we all go*—leaning toward our 50s, 60s, 70s, 80s, 90s, hair graying, wrinkles gathering, experiences accruing, insights accumulating, joy abounding.

No matter what your age or gender, may each of you find inspiration in this book to live bravely and fully, and to use your experience as your most powerful tool in living your best life.

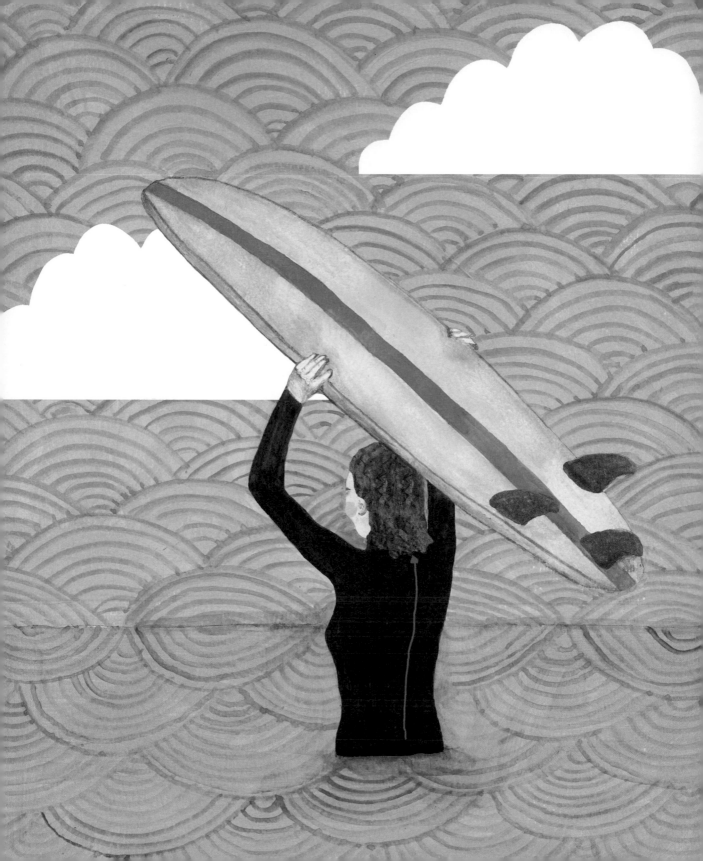

THE SWELL
by
Caroline Paul

One day I decided I wanted to be good at surfing. I was 49.

It probably wasn't the best use of my time, energy, ego. But, what the hell. I loved being pinballed by the waves. I loved the dolphins that often cruised by. I loved the pelicans, dipping toward the incoming swell to catch its lift, millimeters off the water, graceful, calm. Was it pity or disinterest, that glance they gave me as they passed and I attempted to lurch to my feet?

And I loved the actual surfing, those few seconds when I managed to transition from prone to standing, and felt the board lunge forward.

I had some things going against me, things that my advancing age didn't help: knees stiff from almost ten surgeries, back when I was younger; one ankle that didn't move well from an accident. I had fears about these things too, that by the time I was in my 50s I'd be limping and lopsided like someone in her 80s.

So, vowing to get better at surfing wasn't just a lark. It was a war cry against my injured body. Following each surgery, there had been a preview of life at old age: the catheters, the slow movements, the escaping groan as I maneuvered into the front seat of the car. It was more than the physical limitations, though. It was the feeling of fragility, as if I would be blown over by the slightest movement, and shattered into a million pieces.

On the other hand, there's nothing more robust than being in head-high waves, in 52-degree water. I didn't even have to actually catch anything. I just had to be out there.

The plan: for four days every month I would relocate to a house near an isolated Northern California surf spot. I'd leave my partner, Wendy, my cell phone reception, and my pride behind. I'd bring my work, my dog, and my willingness to be beat up by waves.

There were rules: paddle out in almost anything; stay in the water for at least half an hour; arrive at the surf spot already in my wetsuit. This latter commandment was the strangest to most surfers, but I figured the hardest part of the sport was actually getting in the water, so any impediment, especially the hand-to-hand combat with the wetsuit while half

naked in the morning cold, had to be removed. Accordingly, I got into my wetsuit at home, in the garage, then drove to the beach. This was a great idea, until the day I came upon an accident on the freeway. I walked around the middle lanes, looking like Batman. I peered into the shattered cars to offer assistance, but mostly just scared the occupants.

I did paddle out in almost anything. On only a few occasions did I lumber back to my car, dry-haired, unsalted. Once the water had been flat. The other time, I came upon three sea kayakers pulling onto the shore. A great white shark had attacked one of the boats. Eyes wide, faces pale, they spoke over each other like auctioneers. I listened to the story. I marveled at the teeth marks in the plastic. Then, in a move most non-surfers won't understand, I continued to the spot anyway. I looked at the waves for a while. They weren't very good. I decided not to go in. It wouldn't be worth it.

"What waves would have been worth it?" Wendy said later, dismayed.

When I wasn't surfing, I was practicing. I began yoga. I made up a weird jumping routine in the gym. I watched surf videos. I turned 50.

Here's the thing about aging for women: we become invisible. The barista looks right through you when you give your coffee order. The teen on the skateboard narrowly misses you and doesn't even swing her un-helmeted head your way. Straight or gay, you're getting no response when you use your tried-and-true

flirtation methods; the head tilt and slight smile fall flat, the penetrating stare looks creepy, the giggly laugh sounds like a symptom of unadjusted meds.

The ages vary, but it happened to me around this time. I remember the moment. The checker at the store never caught my eye, didn't seem to register a human was even there. He asked the corner of the counter if it had brought its own bag. He asked the rack full of candy if it wanted a receipt. I finally understood what my mother had been talking about.

At first I was a little stunned. I was now officially unvalued by society.

But here's the thing. Invisibility is a superpower. Especially if you're a surfer.

So when people joined me at the surf spot, they didn't pay much attention. If they did, they mostly felt sorry for me. They let me have waves that were rightfully theirs. I faded in and out of their consciousness, depending on how distracting the conditions were. I was left to my own learning curve. I could suffer my small humiliations in peace. This meant I wiped out a lot. This meant that I was often "caught inside." Incoming waves dropped on me like giant pianos from a Saturday-morning cartoon. After one such session, I lurched to shore spitting saltwater from my mouth, wiping it from my eyes, watching it stream from my nose, and a surfer walked over. His eyebrows were lifted, his mouth curved in a half smile. He'd been watching, he said, and couldn't believe I hadn't

just given up, but instead kept paddling to get past the break (and finally did). I said, "Yes, I'm pretty bad at this sport," and gave him a sheepish smile. Where had my invisibility shield gone? Then I realized: from that distance he'd thought I was a man.

"Well, I wouldn't have kept trying," he said. There was admiration in his voice.

I became a better surfer. Not good, mind you, but better. I enjoyed each small advance. Because these are the gifts of being older: little to prove, (mostly) invisible.

A glorious freedom.

So no one noticed but me: last month, there was a quick get-up. This month, a longer ride. Next month, a turn? A graceful exit from the wave? It didn't matter. It only mattered that I was out there, a vague quest urging me on, those endless mistakes, those brief moments of triumph, unseen by most, but celebrated by me.

Caroline Paul is the author of *Fighting Fire*, a memoir about being a San Francisco firefighter; the historical novel *East Wind, Rain*, which is based on true events during World War II; the illustrated memoir *Lost Cat: A True Story of Love, Desperation, and GPS Technology*, considered one of the best biographies of 2013 by *Brain Pickings*; and the *New York Times* bestseller *The Gutsy Girl: Escapades for Your Life of Epic Adventure*, which aims to inspire and encourage bravery in girls.

Beatrice Wood lived a vibrant bohemian life immersed in the avant-garde art movement before she found her passion for ceramics, producing most of her work in the last twenty-five years of her long life.

Born in San Francisco in 1893, Beatrice had a childhood rich in art, travel, and culture, but she was rebellious and restless from an early age. Rejecting her mother's plans for her debut in society, Beatrice left for Europe to study painting and acting. Her parents insisted she return to the States at the advent of World War I, and she immersed herself in the bohemian culture of New York. She met the writer Henri-Pierre Roché and the artist Marcel Duchamp, and the three created the Dada art magazine *The Blind Man*. Beatrice became known as the "Mama of Dada" for her association with and support of avant-garde artists. In the 1920s, she became interested in the Theosophy movement and started following the Indian sage Krishnamurti, following him to California.

While living in Southern California in the 1930s, Beatrice was frustrated that she couldn't find a teapot to match some pottery she had brought home from Holland, so she enrolled in a ceramics course to make her own. Initially believing that she was not meant to work with her hands, she persevered and fell in love with the craft. In her late 40s, she studied pottery techniques and developed her own free and expressive style, creating both traditional vessels and primitive figurative sculptures. She opened a studio in Ojai, California, near her spiritual teacher Krishnamurti, and continued to hone her craft and distinctive style of glazing. Soon, she began catching the eye of galleries and collectors.

She continued to think and work in new ways, creating some of her most complicated sculptural work and writing her autobiography, *I Shock Myself*, when she was in her 90s. She worked daily nearly until her death at age 105 in 1998.

Jennifer Hayden discovered graphic novels at the age of 43, around the same time she was diagnosed with breast cancer. After two decades of writing fiction and illustrating children's books, Jennifer decided she wanted to make comics. Her first book, the autobiographical collection *Underwire*, was published in 2011 and subsequently excerpted in *The Best American Comics 2013*. In 2015, Jennifer published her debut graphic novel—a 352-page memoir about her life and experience with breast cancer. Aptly titled *The Story of My Tits*, the book was named one of the best graphic novels of the year by the *New York Times*, NPR, *Forbes*, and *Library Journal*, among many others. Jennifer's comics, full of moxie and humor, have been featured in *The ACT-I-VATE Primer*, *Cousin Corinne's Reminder*, and the *Strumpet*. At age 55, she's currently finishing a graphic diary spanning the trials and successes of the last three and a half years, along with a new fiction graphic novel.

Lisa: Tell us the germination of your creative journey.

Jennifer: From the start, I was drawing and writing. It was always those two things, and I never wondered until I got out of college which one I would do. In college I majored in art history, but quietly on my own I minored in English. I saturated myself with books because I wanted to be a writer, and if I was going to do art, I was just going to write about it. This was always a war within me while I was learning about both art forms. Then I graduated from college and tried to become the great American novelist and sucked big time. I wrote three really long, very bad novels—even winning a grant for the first chapter of one of them, but that book never panned out. So by the time I had children, I was a disappointed novelist and I craved drawing again. I began

illustrating anything I could get my hands on, and then that turned into illustrating children's books. The problem was that it was a very G-rated community and I swear like a sailor. It was like Mae West going to Sunday school. And then I was in the middle of illustrating a children's book when I was diagnosed with breast cancer.

Lisa: And that became the beginning of a new chapter for you.

Jennifer: I was 43. The world came crashing down around me and I discovered comics. I had read comics when I was a little girl—but then I discovered graphic novels, which had really come of age and gotten interesting. Believe it or not, a *New York Times* article turned me on to them. First I read all of the women's books in the article and then I

branched out and I couldn't stop reading and I said, *This is what I should be doing. This is drawing* and *writing.* I knew I wanted to tell my own breast cancer story to other women who were going to go through it or had been through it. In the course of it, I realized I actually wanted to expand it to a full memoir, of which the breast cancer survivor story would be a piece. And I gave myself a year to read all of the best graphic novels I could find. if I didn't like one, I threw it out the window. Then I made myself sit down and start, not knowing where it would go or how I would do it.

Lisa: What did your process look like?

Jennifer: I did it the only way I could think of doing it; I took my format from Lynda Barry (and I recently had a chance to admit to her that I took it and she threw her arms around me and said, "Of course you did! There's no copyright on this shit! Go for it!" and that really made me feel better), because I just decided it doesn't matter what the format is. It just matters that you begin, and you know what you want to say. Once you have the format, you'll just squirt it in there, like toothpaste. So, I took that and then I decided what size I wanted my little boxes to be. I wasn't going to mess with page layout because I was a beginner. I made a little cardboard square the size I wanted and cut it out, and I used that as a template. I drew panel by panel rather than page by page, the way most artists do, because repeating characters is hard for me. And I would assemble the pages in Photoshop after scanning the individual panels.

Oddly, even though I'd been doing a lot of it, the writing was the hardest part for me. I was afraid I'd fall into the same bad habits I'd had when I was trying to write novels: I was very self-conscious, I was heavy-handed, it never sounded like me. That didn't happen. I was so relieved. But I always kept a notebook next to me and I would decide on the narrative that would go into the panel, first by writing and rewriting until it sounded right in the notebook, and then I would write it down in pen in the panel.

Lisa: From start to finish, how long did it take you to complete *The Story of My Tits*?

Jennifer: Well, I worked on a lot of other things while I was doing it, but it took eight years. I finished it when I was 52.

Lisa: Did you have a publisher when you started it, or did that happen later?

Jennifer: It happened later. You have to understand that I'm a very impractical person. When I lived through breast cancer, a number of things got sort of burned off me and one of them was that I let go of being a working, paid illustrator. I realized I didn't know how much time I had left—and because of that, I just wasn't going to fuck around. I wasn't going to do anything that wasn't absolutely mine and from the heart, and that extended to the words, the pictures, the number of pages, what I included in the story, and the fact that I might have to self-publish it or it might not get published at all. But it was my document and I was going to do it my way. And that's how I

really picked my publisher, and sort of how they picked me.

My publisher, Top Shelf, is famous for publishing really heartfelt, sincere, and wonderful books, and part of the reason is they give their artists a huge amount of legroom and let them do what they're doing. They rejected me about four or five times. I started going to conventions—these publishers are at the convention and you can just go talk to them. I would go talk to this guy and say, "You know, I have a couple of kids, I'm still doing children's book illustrations, and it's kind of slow, but here's what I want to do." And he'd say, "Oh, that sounds good! Keep submitting it, we'll see." And finally, when it was ninety pages, he said, "Yeah, yeah, we'll sign this. We want this." But then I didn't show it to anybody for the next five years. I just did it alone, and he didn't ask for anything.

Lisa: I think that's how more and more people—especially self-taught people who aren't already connected to an industry—get started. They're just very perseverant in working on something that they feel very strongly about.

Jennifer: And ironically I've made more money off this book than off any other project I've done, but I had a feeling that you had to cut your heart out and put it on a platter and serve it to people to get anywhere in this life. I'm pleased that's true, it's just that it's a great deal of internal labor. But if you think you can shortcut that, you can't. And luckily something

happened to me that really cut me open so it was, in a way, easy.

Lisa: By the time you published this novel you were over 50 and you were just starting out—this was your debut novel. Comics and graphic novels are a very male-dominated genre, not that there aren't a lot of amazing women who gained notoriety in the last ten years. Have you faced any adversity due to your age and your sex, and if so, how do you deal with it?

Jennifer: When I'm at shows, I definitely get the look like, "What, are you here with your son? I mean, what are you doing here? Are you someone's mom?" So, that was my only issue. And I think women get much more trouble from guys in the more profitable superhero comics industry. There are entrenched behaviors there that finally are getting rooted out—sexism, discrimination and harassment, and awful shit going on. But in indie comics, I haven't seen that. There are a ton of really talented women in indie comics, and they've done great work. And the guys aren't sitting around saying women don't know how to do this.

So when I got into this, I became part of ACT-I-VATE, a comics studio based in Brooklyn. We used to go out and do things, like New York Comic Con and some other conventions. I was so happy with this environment—it was so freewheeling and welcoming, and I really didn't get any crap from males except young men who couldn't figure out what this old bat was doing at the table.

I would get on these panels, and I was always champing at the bit to explain: *You boys have yet to live the material that you're craving, that you want to write down, and I have lived it. You will have lived it when you have reached my age, and then you will see.* I always think of it as if I'm standing in a cavern out West, and the sides of these caverns that these rivers have carved are so amazing with all the stripes of all the different kinds of rock, and the older you get, you're deeper in that cavern and your life has carved away so much more of this rock. You can look at the pattern and go, *Wow, check that out, oh I see what I was doing there, oh that was crazy, oh you've been wanting to do this all your life,* and it's so satisfying to be standing there seeing this.

I was such a frustrated 20-something when I wanted to write a huge book and I had nothing to say, I mean nothing! And I just hadn't lived yet, and I hadn't opened up, and I hadn't been broken by life essentially and been broken open. If I felt threatened because I had wrinkles and a few gray hairs, and I was kind of out of shape compared to these nine-pound beautiful hipsters, I'd just think to myself, *It's all about what's on the page. Don't worry about this. Worry about your project, get it finished, put it out there, and see what happens.* And that would keep me going.

Lisa: So it's clear you believe your work has something now that it wouldn't have had if you'd gotten into this in your 20s or 30s. Why is that?

Jennifer: My emphasis has always been about how much life you can get onto the page. If you're too critical and too hung up on technique and the tradition of technique, then that's very hard to do. I know that I squelched the hell out of that life-giving part of myself in my 20s and early 30s. I was very disapproving of my own work in those days, and I think if I'd gotten into comics then, I would've screwed them up for myself just as badly as I screwed up writing.

Then I had kids. That is just such a great way to get rid of your dignity. And it makes us all pretty democratic and makes us realize that, in spite of our failings, we have got it on the ball—so there's that for a confidence booster and a channel for creativity.

And, undoubtedly, going through breast cancer helped, too—I had one interviewer ask me if this book would exist without cancer, and I said no. That experience did the rest of what I had to do to my dignity and my self-control and my internal editor. I just threw it completely to the wind and said, *I'm going to do this naked on horseback.* I didn't care anymore. That's a part of the speed and whirlwind of distraction that occurs at middle age. I'm sure my anxiety and my ADHD decreased with time, and as the things pushing against me increased—two kids, pets, people around me, aging parents—those things too, putting pressure on me, forced me to crystallize whatever it was I was doing and what I was wanting to say. There's no time to write all day and throw it all in the trash, the way I used to do in my 20s.

Lisa: What advice would you give to women who are just getting started with a new challenge later in life?

Jennifer: It's funny, I read this quote in *More* magazine, embarrassingly enough, and they said that most women in middle age go back to school for knowledge, thinking that they don't know enough to, say, start their own business or write a novel or whatever it is. This woman's advice was: don't do that. You already know what it is, just do it. And that really struck a chord with me because that was my attitude. I thought it was just because I had breast cancer, but I realized, looking around after a while, that a lot of women at that age were having the same attitude I was having, which was, "You know what? To hell with this. I'm not going to patriarchy school to learn how all you white boys do your stuff. I'm going to just do it." And a big part of my book and my experience with breast cancer was this attachment I formed to this goddess image. I was feeling as if she was transmitting this book to me, honestly, if I'm going to be completely weird about this. I would feel very certain about what I was putting down on paper because I could feel her approval and encouragement, and it was very internalized and very deep. I just finished reading Sue Monk Kidd's book *The Dance of the Dissident Daughter*, about discovering the sacred feminine inside her after having been raised in the very masculine Baptist church. I was raised to be a feminist in my family, so I had a different trip—but you can still hold yourself down in whatever pursuit you're in. So my advice is just get out there, take off your underpants, and just run into the ocean and do it. You already know what you have, you already know what to do, so speed it up, don't slow it down.

Vera Wang pursued a career in figure skating and spent fifteen years as an editor at *Vogue* before her own wedding at age 40 propelled her into the world of fashion design and her name became synonymous with matrimonial elegance

Vera was born in New York City in 1949 to a wealthy immigrant family from Shanghai, China. As a young girl, she was passionate about figure skating, and she devoted much of her childhood and teen years to arduous practice and frequent competitions. At 19, she competed for a place at the 1968 Olympics but failed to make the team. After graduating from college, Vera transferred her focus and dedication from figure skating to fashion and was hired as an assistant at *Vogue* magazine. She quickly impressed the staff and worked her way up to becoming one of the magazine's youngest fashion editors. In 1987, after fifteen years at *Vogue*, Vera was passed over for the position of editor in chief (the position went to her friend Anna Wintour), and she left the magazine to join the design staff at Ralph Lauren.

A few years later, as she was planning her wedding, Vera became frustrated with the selection of bridal wear available. Recognizing a need for sophisticated gowns, she opened her first bridal boutique in 1990 and began to hone her skills as a fashion designer as she entered her 40s. She revisited her first passion when she designed an ensemble for figure skater Nancy Kerrigan for the 1994 Olympics, a sleek silhouette that captured America's attention. Her elegant and modern designs quickly became the standard of not just bridal wear but of Hollywood glamour as she began designing event gowns for actresses and celebrities. Over the past twenty-five years, her design empire has grown to include ready-to-wear, fragrance, jewelry, and even dinnerware. Vera, now in her 60s, continues to put her own distinctive touch on all of it.

Christy Turlington Burns is a mother, social entrepreneur, model, and founder of the maternal health organization Every Mother Counts (EMC). She is best known as one of the most famous supermodels of the 1990s, when she graced the covers of countless international fashion magazines and was featured in notable campaigns for Calvin Klein, Chanel, Marc Jacobs, Versace, and Maybelline, to name a few. Two decades later, at the age of 41, Christy became an influential activist, founding Every Mother Counts, a nonprofit organization working tirelessly to improve access to maternal health care in the United States and developing nations abroad. Christy has since produced three documentary films on maternal health and become an avid distance runner, completing five marathons. In 2015, at the age of 47 and with only five short years as a runner, she ranked among the world's elite runners when she qualified for the Boston Marathon. Christy has been recognized as one of *Time's* 100 Most Influential People and *Glamour* magazine's Women of the Year. In March 2016, EMC was recognized as one of *Fast Company* magazine's Top 10 Most Innovative Companies in Not-for-Profit.

Lisa: You started your organization Every Mother Counts at age 41. How did you become interested in maternal health?

Christy: I had a really complicated birth with my first child. In the weeks postpartum, when I was recovering and trying to learn from what had happened, I came across the startling statistics for deaths from complications during childbirth for girls and women around the world. I also learned that the complication I had experienced and survived was the leading cause of maternal death. I couldn't "unknow" that information, and I started to actively think about how I could use this experience to help others going into motherhood.

I had the good fortune to be invited by a large NGO called CARE to travel to Central America, which is where my mom is from and where I spent many, many summers as a child. I was pregnant with my second child when I visited, and it was there that I had the actual aha moment: *If I had delivered my daughter in one of these villages without paved roads, what would've happened?* And I was pretty certain in a lot of other parts of the world, including in the United States, I probably wouldn't have survived. And that blew me away. From there, I knew I had to do something, and that's how Every Mother Counts was born.

Lisa: You became a marathon runner in your 40s, and there is a deep connection between your running and your leadership of Every Mother Counts.

Christy: It happened kind of accidentally. In 2011, we had a call from the New York City Marathon saying they had ten spots they wanted to give to Every Mother Counts, and we could do whatever we wanted with them. As soon as we got the call, suddenly I thought, *Well, wait a minute. This could be on my bucket list. I can't imagine having a team and not being on it.*

Lisa: I read somewhere that prior to running marathons, you had never run more than 3 or 5 miles?

Christy: Yes, I ran short distances as a kid and loved it. As an adult, I would run periodically just for exercise. In the early days traveling for my career, most hotels didn't have gyms. So the best thing to do was to get out and run. But I would run no more than 4 miles maximum.

The year before I did the New York City Marathon, a friend had asked me to chair a 5K for lung cancer on Long Island. My dad died of lung cancer, so when they asked me, I was like, "Sure, absolutely. Of course I'll do it." And I dedicated the race to him. I trained a little bit, but it was not out of my capabilities. I did that race in August of 2010, and it was brutally hot. It was miserable. I had gone to a 40th birthday party the night before, so I was up late, and I remember thinking, *Oh my gosh, it's so painful!* But then it also occurred to me, *Oh, I'm so*

lucky to be able to use my lungs, to be able to breathe. And so it also felt really empowering.

Lisa: How much longer was it until you ran a marathon?

Christy: The next year! When Every Mother Counts received the marathon spots, I started to train. And then it came back to me—what I loved about running when I was a kid, all the things that my dad tried to instill in my sisters and me about health and fitness and being strong. Even more motivating was the way I've been able to connect running to my organization and our mission—in that distance is a big barrier for women and childbirth around the world. So we're able to communicate that every time we run.

Lisa: And now you are running your fifth marathon just a few years later. And you've qualified at the age of 47 for the prestigious Boston Marathon.

Christy: It's something I love. It's become a kind of meditation. It's part of my work, part of my mental health. Setting a goal, training, learning about my body, taking time for myself to just be disconnected and outside and on my own—all of those things have become not only appealing, but also necessary. I need to have that time for myself and it has allowed me that. Now I would never say, "I run." Now I say, "I'm a runner." And that feels good.

Lisa: What advice would you offer to older women who are just getting started with running?

tHE POWER of YOUR mIND IS SO INTENSE aND STRONG tHAT If YOU tELL YOURSELF tHAT YOU caN't, tHEN Of COURSE YOU caN't, aND YOU WON't.

CHRISty tURLINGtON BURNS

Christy: I'd tell them, "I didn't like it at first either." Not that you should do something that doesn't feel natural or right! But you have to do it enough times to break through the part that feels difficult. I think most people are not patient enough to do anything long enough to get through a difficult transition. I also learned from reading that book *Born to Run*—it's a beautiful book, and part of it is about how running is such a human act—it's what humans have done from the beginning of time. Our

species evolved to run and to run distances. We're such a sedentary population now. The book also discusses how running is play. You go back to being a child and remember that you used to love to run! And so I try to just think about running differently.

Running is also one of the ways you can *do something*. You can raise money and awareness, you can get people to be involved, and you can be part of a team. I feel like almost

anyone can go from couch to 5K, and so we try to partner with races where there are different distances so people can feel like, *Oh, I can do that*, and they can start there. By not committing to something that's too big, slowly you start to see that when you surpass your last mileage, you will find yourself saying, *I never thought I'd be able to run this far. I can't believe I ran 16 miles!* The power of your mind is so intense and so strong that if you tell yourself that you can't, then of course you can't, and you won't. Conversely, if you tell yourself you can, you will find joy in pushing yourself further.

We don't allow ourselves to get to the threshold very much as a society. I think it is super exciting at any phase of your life to be able to push yourself to the edge without hurting yourself. It's really exhilarating and brings that life force into a really practical place. I think you learn so much about yourself and about others by putting yourself to that test.

Lisa: You had a busy decade. You founded Every Mother Counts, you ran five marathons, you produced and directed three documentaries, and you've been raising two kids. How would you characterize the experience of the last decade?

Christy: I have more energy than ever before, and that's in part because I feel so passionate about the work I do. It's so rewarding on a daily basis, and it feels like everything I do in this space with the organization feels so rewarding and needed. To have that sense of purpose, not in a fleeting way but in a real

consistent way, is really exciting, and that's probably the most different than in any other time in my life.

When I was younger, I had those feelings for brief moments, but now I feel like my world is in sync. And I don't mean in the sense of balance, because I don't really like that word very much, but I mean in the sense that I'm standing here in my office and I can see where I live a few blocks down, and I can see my kids' school, and I can see that this hub of Every Mother Counts is growing and resonating, and all of it feels like concentric circles.

I think in our lives, generally, there are these phases and you know when you get through *this* phase, there's *that* phase. And I don't see this phase ending. It's like being a mom—once it happens, you are in it forever. And as long as I am healthy and able, I want to give back. I understand that my health is a privilege. I am grateful in every moment that I have the capacity to breathe, that I have two arms and two legs, and the mental capacity to think things through, and the communication skills to connect with others. Because I travel a lot to places where people don't have privilege, I think about my own a lot. There aren't many days when I am not very, very grateful.

Louise Bourgeois

made art as a means of exploration and therapy. She spent her life drawing, painting, and making evocative sculptures but didn't garner the world's attention until she was 70 years old.

Born in Paris in 1911, she spent her childhood in an apartment above the showroom where her parents sold tapestries. On the weekends, her family would head to their countryside villa for antique tapestry restoration work. There Louise learned to sew and paint by repairing the missing elements on damaged tapestries. In her early years, she struggled with her father's ten-year affair with her live-in English tutor. She felt betrayed by both her parents—her father for abandoning her, and her mother for tolerating it.

Louise never intended to be an artist. Her passions were mathematics and philosophy, and she studied them for twelve years at Paris's Lycée Fénelon, followed by a stint at the Sorbonne. When she came to the realization that math offered no certainties, she "turned towards the certainties of feeling." Between 1932 and 1938, she studied art under a number of teachers, paying for her classes by working odd jobs.

In 1936, she met an art history student named Robert Goldwater. Within two years, they married and moved to New York City. She began making sculptures in the late 1940s and was ahead of her time, anticipating movements—human form, installation, minimalism—that would become popular in the years to come. However, when her father died in the early 1950s, Louise disappeared from public view. During this time she was immersed in psychoanalysis, but she didn't stop working. When she emerged from her long hiatus in her 50s, her new body of work was strange, questioning, and abstract. And the critics noticed.

Around the time her husband died in 1973, her work hit a new high. She accepted honorary degrees and commissions for public art. Then, her 1982 retrospective at the Museum of Modern Art—the first retrospective of its size that the institution had ever held for a woman—made Louise Bourgeois, then 70, famous worldwide. As part of this exhibition, she published her diaries, took press inquiries, and was openly autobiographical in a way she'd never been before. Her retrospective left her with a confidence that propelled her work to continue to evolve until her death at age 98 in 2010.

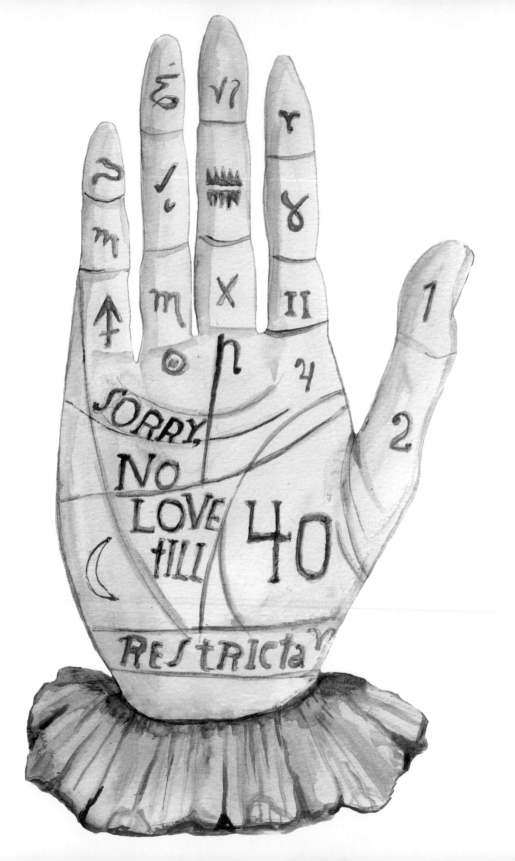

BECAUSE LOVE LET ME BE
by
Jennifer Maerz

When I was 25, a palm reader decreed that I wouldn't fall in love until I was 40. She grabbed my hands, fingered the stories stitched into my palms, and made her pronouncement from the window seat of a San Francisco café. "The lasting love of your life won't arrive until you're 40."

Forty?!?! My heart sank. "Are you sure?" I asked. Palm readers had been eerily accurate about my life before, and this prophecy felt like a punishment.

"Yes," she said. "I'm getting a very strong reading on this."

I walked away shaken. I didn't want to wait for love. Five years into a great relationship, I thought I'd already found it. I'd met my boyfriend working at our college newspaper in Santa Cruz. I loved his wry humor and the way he'd narrow his brown eyes into a winking squint. I'd brought him home to meet my parents three weeks after we first kissed. One month later, we were nestled into the damp couch on my front porch when his face turned serious. He said he loved me. I loved him, too.

I followed him to San Francisco. We moved in together, cared about each other's parents as our own, and wrote longing letters to one another when we were traveling alone.

At 25, I assumed that we'd always be in love, that he'd always cook me homemade ravioli and I'd always get him tickets to underground rock shows. The palm reader's words haunted me that night.

But as my 20s continued, I also needed more than our relationship offered. My boyfriend became a political reporter in D.C. and then in Sacramento, and I became a rock critic in Seattle. We left each other in separate cities often, with the promise that our situation was temporary. I got lonely without him and explored temptation in the corners of the after-hours parties I inhabited with my punk friends. I drank enough to pretend that those illicit kisses evaporated from memory with the smog of cigarette smoke.

After eleven years together, my boyfriend asked me to marry him as we stood under an umbrella in DUMBO. My heart leapt with

excitement. But then I found myself twisting my engagement ring diamond side down when he wasn't around. I loved him, but the flashy rock was an audacious symbol of adulthood I couldn't embrace.

And yet, when my fiancé announced one year after our engagement that he'd fallen out of love with me, I wanted nothing more than to patch the sinkhole between us. But by then it was too late. We were living in silos. We saw a therapist who told us, after one session, that our relationship was over. My fiancé did the honors the day after Valentine's Day. We were on a drive between our cities and he asked to be let out at the nearest train station. He wanted to go back home, alone. I didn't talk to him again until a mutual friend's funeral nine years later.

I didn't want to be 32 and single. I didn't want to figure out where to take my vacations or how to manage bills by myself.

I went through rough patches. I missed my ex terribly. I'd cancel on friends because it felt better to watch episodes of *America's Next Top Model* and cry my eyelids shut than to pretend I was enthusiastic about being a single lady on the dance floor. On Valentine's Day, I'd ache to become invisible until February 15. And when the latest in my series of three-month relationships had run its course, I stumbled out of yet another apartment, heartbroken.

But over time, I began taking healthy risks and gained confidence.

After working as a rock critic for a decade, I quit the music business. I hated drinking too much and being around other drinkers all the time, and I realized a good night's sleep grounded the anxieties that had been building in me for years. I let go of the glamour I'd associated with dating musicians, whose attention spans shrank the minute they returned to their tour buses.

I also had fun. I had flings with men whose lives intrigued me. I lived out weekend fantasies with an air guitar champion from Los Angeles, a Danish rock star, an Australian concert promoter. And then I got sick of having sex with transient matches and started saying no to anything that didn't feel right for the long term.

I got lasting intimacy from my friendships with women, friends who were also single and excited to drive down to Los Angeles for a psychedelic rock festival, my car loaded up with their mixtapes. These women would spend weekends with me floating down the Russian River, or evenings looking at the stars from a rented house in Stinson Beach. I'd never felt love like this with friends before.

I developed a unique bond with my sister when we started taking annual adventures together, trips I previously would've taken with a boyfriend. We ate piranha in Buenos Aires, slept in Gram Parsons's Joshua Tree hotel room, and visited the hoarder home of an Elvis obsessive near Memphis.

I realized I'd spent my teens and 20s trying to close the gap between myself and the boys I'd met. I'd hitch myself to what they were accomplishing and hope that by proxy I could earn accolades, too. I had a fire inside but no idea how to channel that burn on my own. I'd confused being aggressive about sex and love as being assertive in the world at large.

It wasn't until there was no man by my side that I understood what I could do alone. I didn't have to contort into a portrait of what my exes needed me to be. I could make spontaneous decisions about my career, my lifestyle, my travel plans.

By age 38, I was focusing little energy on meeting a romantic partner. Of course, that's when I met the guy the palm reader envisioned.

I was working as the editor in chief of a popular San Francisco publication and building a healthy meditation practice. I was happy enough being single, but when a friend mentioned a handsome friend who loved books and movies as much as I did, I agreed to let her set us up. From the minute he walked into the bar, we couldn't stop talking. He told me he wrote fiction and made furniture and played hockey. He was omnivorous and encyclopedic in his knowledge about music. By last call, I couldn't believe this blue-eyed Midwestern guy with chiseled cheekbones was shutting down the bar with me.

We went on two dates and then I left for a ten-day silent meditation retreat. I spent my days

with the Buddhists facing every fear I'd stored inside. On the tenth day, we were instructed to forgive our mental tormentors, and I released the heavy hurts I'd been hoarding for years. But I also felt seized by overwhelming love for the Midwesterner. We met up the night my retreat ended, and he'd written me a poem for every day we'd been apart. I couldn't tell him I loved him fast enough—but I waited two more days until he said it first.

Two years later, when I was 40, we got married in Big Sur. He'd proposed to me at the top of the Fairmont Hotel—the same place, he knew, that my dad had proposed to my mom. Score one for the palm readers of the world.

I have friends in their 30s who sometimes wonder if the partners they aren't so sure about are the ones they'll love for the long term. They'll ask if what they feel is enough, knowing that by saying the question aloud, it's probably not. But they don't want to let go, for fear of traveling the world alone, for a clock that will strike them unlovable at a certain age. I feel their pain. I'd also been terrified that I wasn't strong enough to be on my own.

I realized, though, that some of us need to be solo explorers in our 30s. We need to go from pushing up against the borders of our 20-something relationships, suffocated by what we can't have, to experiencing what we really want.

That doesn't mean being married at 40 is a fearless endeavor. Trying to get pregnant is so much harder than I expected. And occasionally

I'll get anxious about losing my husband to some terrible ailment as we get older.

But in the end, falling in my deepest love at 40 has given me time to build my life based on who I am, instead of what I'm being forced to set aside. I understand that great uncertainty can foster great opportunity. And for those lessons alone I'm grateful that romantic love let me be until I was an age to really appreciate myself as much as I appreciate my partner.

Jennifer Maerz is a freelance writer, an editor, and a beachcomber who now lives in Portland, Oregon. Her personal essays and articles about the arts and culture have appeared in RollingStone.com, Cosmopolitan.com, Refinery 29, the *San Francisco Chronicle*, the *Stranger*, and the *Bold Italic* (where she worked as the editor in chief), among other places. She can go through a box of black licorice like nobody's business.

Emily Kimball calls herself "The Aging Adventurer." In her 40s, she decided that she wanted a job outdoors and joined her local community's recreation department. Since making that leap forty-three years ago, over time, Emily fell more deeply in love with the outdoors and began to traverse thousands of miles by foot and bicycle. She's hiked over 2,000 miles along the Appalachian Trail, cycled 4,700 miles across the country, and trekked 192 miles across northern England, all after her 60th birthday—and that doesn't include endless other adventures leading to the present day. Now at 85, Emily is the author of two books, including *A Cotton Rat for Breakfast: Adventures in Midlife and Beyond.* As the owner of Make It Happen!, a lifestyle consulting firm dedicated to challenging people to achieve their dreams, Emily tours the country speaking as an expert on creative aging, risk taking, and overcoming obstacles. She still gets outside (a lot!), and is currently planning her next bike tour.

Lisa: You landed your dream job as outdoor recreation manager for Chesterfield County's Recreation Department at age 48. Tell us about your journey up to that point. What had you done with your life before?

Emily: I have a master's degree in sociology and worked right out of grad school as a community organizer in a South Philadelphia neighborhood, out of United Neighbors Settlement. The neighborhood was mainly Italian, with large numbers of African American and Jewish populations moving in. It was a challenging job getting people to work together for the good of the community. After that, I worked for the Philadelphia Commission on Human Relations as a field representative. The new housing law had just passed, along with employment laws. I worked in many interesting situations trying to make those laws work at the grassroots level.

Lisa: Why did you make the career shift? What led to it?

Emily: I was an at-home mom for fourteen years. I got divorced at age 42 or so, and I took a job with the State Office on Aging working as a field representative. It was then that I decided I wanted to make my great love for the out-of-doors into a career. I went back to school for eight months, studied biology (plants, birds, mammals, ecology, insects, etc. . . . I thought I had died and gone to heaven!), and did an environmental internship at Glen Helen Environmental Center in Ohio for five months. Then I traveled across America interviewing for environmental jobs. I lived on

$200 a month, camping and cooking meals over my camp stove, and letting my ex-husband care for our three children, then 10, 12, and 14 years old (that's another long story). During this time, I also hiked down the Grand Canyon, canoed 200 miles on the Suwannee River, and spent ten days at a wilderness survival experience in Utah.

I ended up securing my dream job as the outdoor recreation manager for the Chesterfield County Parks and Recreation after coming home empty-handed from my cross-country job search. I worked twelve different jobs that year to support my family, while still hoping to find a local outdoors job.

Lisa: You are a longtime outdoors enthusiast, and you refer to yourself as "The Aging Adventurer." How did adventuring start for you and why?

Emily: I did a few bike trips while in college and always played tennis and baseball as a kid. We ice skated on the frozen streets of Rochester, New York. But I really became more of an adventurer in my 40s—I took a class in backpacking for women over 40 and joined the bike club to supplement my life as a single parent. I made this career change because the outdoors was my passion, and since I would probably have to work for the rest of my life, I wanted to work at something that I believed strongly in and felt passionate about.

Lisa: What do you do to take care of yourself and stay in shape between long-distance hikes or bike tours?

Emily: I take care of myself by aiming to be active five days of the week. I walk for an hour before breakfast, play doubles twice a week with a 55-plus group, bike on Saturdays with the club (25 miles), and in the summer, I swim almost daily in the great Olympic pool where I live. I also do some backpacking, but that is getting harder, and, of course, I hike.

Lisa: How has the experience of being out in the wild changed with age?

Emily: I find that I am happiest when I am out in nature. It is where I go for comfort. Being active and in nature keeps me going. That hasn't changed with age, but it is harder to find pals my pace to do these things with, so often I do them by myself. Of course, I am a lot slower at them and have given up cross-country skiing due to balance problems, and loaded touring (where you carry everything on your bike) is just too hard now.

Lisa: You're now the author of two books, a public speaker, and you even run workshops focused on creative aging. Why is creative aging important for you?

Emily: I speak about creative aging, my favorite topic, because we now have twenty to thirty years of healthy living after leaving the workforce, and I want to inspire people to make the most of this time—to ignore the ageism in our culture and just go out there and live their dreams. My favorite topic to speak on is "Redefining Old Age for the Twenty-First Century."

Lisa: What advice would you give to older women who are considering pursuing a passion, exploring something new, or changing their life in a significant way and might feel they are "over the hill" already or nervous to do something new?

Emily: My advice to older woman is to take risks, try new things, and don't let failures get you down. Learn from them and then move on. This is also my main message in my recent book, *A Cotton Rat for Breakfast: Adventures in Midlife and Beyond*. You're not over the hill. You have twenty or more good years to go for the things you put off in the busy middle years!

Lisa: What's next on your horizon?

Emily: I leave June 13 to join a bike tour on the 240-mile Katy Trail in Missouri. I am calling it my last hurrah, but friends tell me it probably won't be. It is a 2,000-mile car trip to get there, and I will camp at nice parks, swim, and visit friends along the way. And I plan to stay afterward for a couple of days and do a canoe trip on the river and maybe some more biking before coming home. In April, my son and I did a seven-day bike tour in Florida. We always do a Florida tour each spring.

WOMEN MAY BE THE ONE GROUP THAT GROWS MORE RADICAL WITH AGE.

GLORIA STEINEM

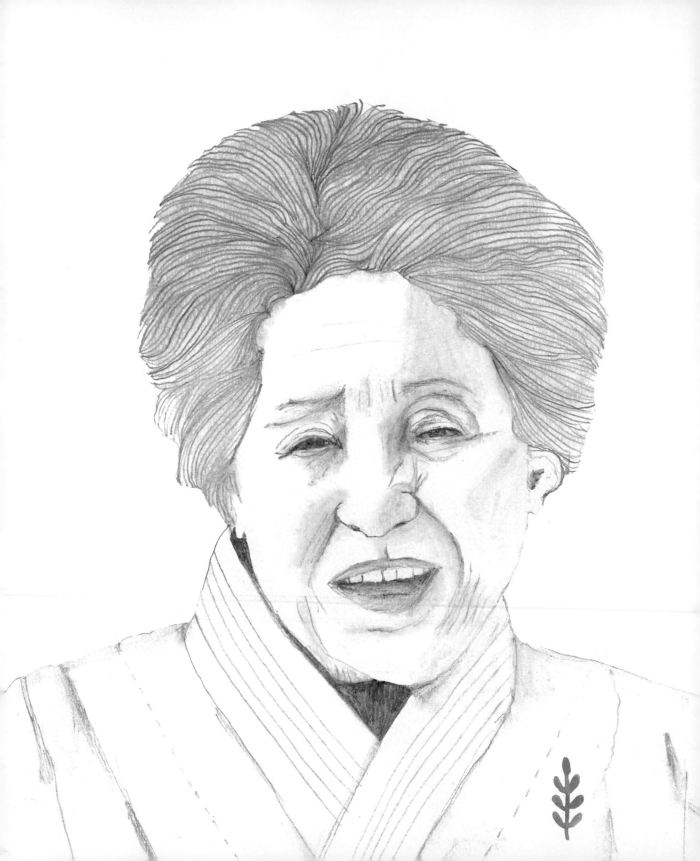

Sensei Keiko Fukuda became the highest-ranked female judo master in the world at the age of 98, after enduring decades of discrimination from the male-dominated Kodokan.

Born in Tokyo in 1913, she was the granddaughter of Hachinosuke Fukuda, a samurai and master of jujitsu. While her Japanese upbringing was conventional at the time—spent practicing flower arranging and calligraphy—her life changed at 21 when Jigoro Kano, founder of judo and one of her grandfather's former students, invited Keiko to train with him at his martial arts center, also known as a dojo. Standing less than 5 feet tall, Keiko was an unlikely master.

Judo is related to jujitsu, involving a combination of holding and throwing techniques, with strength and balance. Despite her physique, Keiko excelled. She was so dedicated that she refused an arranged marriage for fear of having to quit the sport, and she became an instructor in 1937. Jigoro Kano died in 1938, and Keiko developed an expertise in a gentler form of judo called judo kata. At the age of 40, she joined a select group of women as a fifth-degree black belt, also known as fifth dan, and moved to the United States, where she taught for several years. She then returned to Tokyo, demonstrating women's judo at the 1964 Summer Olympics.

In 1966, she relocated to the United States and later became an American citizen. After twenty years of the Kodokan refusing her advancement, a petition was held, and in 1973, 60-year-old Keiko became the first woman to hold the rank of sixth dan. A year later, she founded the Keiko Fukuda Joshi Judo Camp, the first women's judo training camp, and in the late 1980s she established her own women's tournament. For more than forty years, she taught women from all over California's Bay Area at her dojo in San Francisco.

She remained a sixth dan for more than thirty years, until the Kodokan granted her ninth dan, the second-highest ranking possible, in 2006 at age 93. This remains the highest ranking a woman has ever achieved. Keiko was 98 when the U.S. Judo Federation promoted her to tenth dan. The Japanese government recognized her with the "Order of the Sacred Treasure" for her contribution to the sport. Keiko continued to teach judo at her dojo until her death at the age of 99.

ROARING OVER THE TIPTOE

by

Heather Armstrong

I am writing these words five weeks after running the Boston Marathon, my second time running 26.2 miles. The first time I ran a marathon I was 36 years old and crossed the finish line with broken bones and emotional bruises so profound that they would lead to the end of my ten-year marriage. This time I walked away from the finish line at 40 years old, content, an effortless and knowing grin on my face, back to a hotel room I was sharing with no one.

The journey between the first and second marathons is one I did not anticipate, but it would change the entire fabric of my life and how I feel about being a woman in an age group that is so frequently written off. Little did I know that the difference between 39 and 40 is that 39 is considered "older." Forty? Forty is considered "old."

Anyone who is vaguely familiar with the trajectory of my career would point to a younger version of me, to the year that my second daughter was born, and say, "There. That's when she peaked." I was 34 years *young*, had just finished a tour for my *New York Times* bestselling book about the postpartum depression I'd experienced with my first daughter, and

was running a wildly successful blog that had pioneered an industry of online voices making money through storytelling via ad networks. I was also very much in love with my new infant and the chance she had given me to experience early motherhood in a way that I had not had the first time around because of my depression. On paper, that year looks exactly as I had always imagined it would look when I became successful, the lines and curves of it matching perfectly with the teenage illustration I'd carefully crafted and referenced in my 20s and early 30s.

But two years later while training for that first marathon, while spending hours alone on sidewalks and trails jostling my body (literally and metaphorically) into something new and strange and complicated, I reached a level of self-awareness that had unknowingly eluded me throughout my successes. I thought I had been present and careful with the choices I'd made as a mother and business owner, but what came to the surface during all those miles spent alone was *I am not this.*

I am not this.

This was not only the commodity that I had become as the sole source of income for my family, but it was also the passionless partner and disengaged friend I'd transformed into because of what I thought it meant to be a married woman with a family. This was modeled for me by my mother, who had suppressed her true self and all her interests my entire childhood in sacrifice to my father and a religious notion that a woman has a specific place in the household. And even though I was the primary breadwinner in my family, I had for years been censoring and sanitizing and punishing my true self because the father of my children did not approve of the wild-eyed woman he had originally fallen in love with.

Fortunately, my mother also modeled for me the step I took next when I blew the whole thing up.

I came home from that first marathon on crutches, broken outside and in, and when I asked for my separation shortly thereafter I knew that I could quite possibly be committing career suicide. I was "the mommy blogger," she who had made a purported fortune writing about her happy family and marriage with a humorous irreverence that masked all of the very real, very damaging problems plaguing the everyday. Divorce was not supposed to be part of the storyline.

But I could not continue to live what had become a lie, could not continue to tiptoe inside my home when I wanted instead to roar and break through walls. Not surprisingly, the next two years were the hardest, most agonizing years of my life. When my divorce played out publicly, like I knew it would (in the *New York Times*, the *Huffington Post*, and even in my hometown newspaper), a portion of my audience chose sides. At the same time, my industry was rapidly fracturing, and readers began scattering to various corners of the Internet. What was once a business model focused entirely on authentic storytelling quickly turned into manufactured "stories" about products that brands wanted to sell with my own life as the backdrop.

Masking my unhappiness while writing those posts brought me to the brink of another stay under neuropsychiatric supervision.

There were moments during the darkness of my divorce when I thought back to the year of my second daughter's birth and let nostalgia mislead me, if only to stop myself from bleeding out. But I'd always come back to the sound of my two feet, one after the other, carrying my body past mile 16, past mile 17, past mile 18. I could not unlearn what I had learned throughout those thousands of steps. The year of my second daughter's birth was not "peace," as nostalgia would have had me believe. It was one stretch of pavement on the way to it.

I also frequently looked ahead to the end of the contract I had with my ad network, an event that would closely coincide with my 40th birthday. As freeing as the end of that agreement would be, I was much more terrified by what it meant. Was it the end of an era? Could

I possibly transition what I had built over the previous fourteen years into something just as lucrative, especially when I didn't have the young 25-year-old face to help propel it? Would people find out that I really had no idea what I was doing all along?

How do I do this *all alone*?

My mother didn't start her career until after the age of 40, after she divorced my father and had finally embraced the notion that she should never be anything but *all* of herself. Over the course of twenty years she worked her way up from being a district sales manager in Avon (the most basic managerial role in the company) to becoming the regional sales director for the western United States. Here I was worried that it might be curtains for me at the same age my mother was when she was just breaking out her running shoes.

"You need to build another boat" is what my life coach, Rachel, told me after our first meeting. I hired Rachel after I asked my mother to a one-on-one dinner in desperation, eager to hear what advice she would offer to what I saw as the washed-up, burned-out, and weary shell of who I once was. Her answer was not what I had expected.

"You have a head start," she told me.

But wasn't I at a dead end?

"Hire one of those . . . *life coaches*? Is that what they call them?" she continued. "Find one you

like and let them guide you. Darlin', I didn't even wade into the waters until after I was 40, and look at what you've done. You have so much more to do."

First of all, my mother is not the type of person who would normally suggest a life coach. I honestly thought she might tell me to go back to church and pray about it. Second, it was the first time someone had given me permission—or what I perceived to be permission—to be proud of what I had done, of what I had built. Because in my industry, you're only as good as your last blog post.

But that's not true. *I am not my last blog post. Look at what I have done.*

I am not this.

I worked with Rachel for over eighteen months, and not only did she help me build another boat, but she also *gave me permission*. If she reads this she'll shake her head and say, "Did I teach her nothing?!" Because I don't need permission to give myself credit or to cut myself some slack or to take a break. Turns out those things are a lot easier to do when you get "old."

I was 39 years *old* at the 9-mile marker of **a half** marathon in Tanzania when I started to get the hang of it. I'd hit a wall in the 90-degree heat and could feel my body shutting down.

"You get to walk, Heather" is what I told myself, something I had never before let myself do in a race. And so I walked. Others ran past me

while I walked. I saw them disappear into the fog of the heat ahead, knowing their finishing time would be faster than mine. But not better. Just faster. Two very different measurements.

How happy I was to have finished upright. I finished! *I am this!*

In the few months leading up to the end of my contract with my ad network, my excitement around the transition and the significance of my 40th birthday grew. Because I had been scared for so long. Scared of disappointing my ex throughout our marriage, of disappointing my audience, scared of aging out of my industry, scared of losing my audience to talent far younger.

I had been scared that I was only as good as my last blog post.

Then I turned 40. I got "old." The fear fell from my limbs like dead weight because for the first time in my life I realized I was living the fullness of all that is me. *All of me.* Success, I had come to realize, was not a book tour or a paycheck or an award-winning blog or an age. Success was finding myself. How glorious turning 40 turned out to be.

Heather B. Armstrong is widely acknowledged to be the most popular "mommy blogger" in the world. Her website, dooce®, has twice been listed as one of the 25 Best Blogs in the World by *Time* magazine. *Forbes* listed dooce® as one of the Top 100 Websites for Women and named Heather one of the 30 Most Influential Women in Media. She is a *New York Times* bestselling author, with 1.5 million Twitter followers and an actively engaged audience.

LILIAN JACKSON BRAUN

DIDN'T PUBLISH THE FIRST IN HER WELL-KNOWN SERIES OF CAT DETECTIVE NOVELS UNTIL SHE WAS 53. SHE WROTE 29 BOOKS IN THE SERIES AND ENJOYED A 45-YEAR CAREER TILL HER DEATH AT AGE 98.

LESLIE JONES

WAS 47 WHEN SHE BECAME A "SATURDAY NIGHT LIVE" CAST MEMBER.

LOONGKOONAN

IS AN AUSTRALIAN ABORIGINAL ARTIST WHO CONTINUES TO PAINT AT THE AGE OF 105.

RUTH FLOWERS,

AKA DJ MAMY ROCK, SPUN RECORDS AT DANCE CLUBS & CELEBRITY PARTIES UNTIL THE AGE OF 82.

EXTRA-ORDINARY CREATIVES

VIRGINIA HAMILTON ADAIR

PUBLISHED HER FIRST BOOK OF POETRY WHEN SHE WAS 83. HER POEMS HAVE SINCE BEEN FEATURED IN THE "NEW YORKER".

HARRIET DOERR

WAS 74 WHEN HER FIRST NATIONAL BOOK AWARD-WINNING NOVEL WAS PUBLISHED.

EVE ENSLER

WROTE THE "VAGINA MONOLOGUES" AT AGE 48.

JULIA MARGARET CAMERON

DIDN'T PICK UP A CAMERA TILL SHE WAS 48. THE MET NOW DESCRIBES HER AS ONE OF THE GREATEST PORTRAITISTS IN THE HISTORY OF PHOTOGRAPHY.

KATHRYN JOOSTEN

LANDED HER BREAKOUT ROLE ON AMERICAN TV SHOW "THE WEST WING" AT AGE 60. SHE NOW HAS TWO EMMYS.

VIVIENNE WESTWOOD

DIDN'T HAVE HER FIRST RUNWAY SHOW UNTIL SHE WAS 41 AND DIDN'T GAIN WORLDWIDE FAME UNTIL HER 50S.

ANNE RAMSEY

MADE HER FIRST BIG SCREEN APPEARANCE AT 45 AND WAS LATER NOMINATED FOR AN ACADEMY AWARD.

SUE MONK KIDD

DIDN'T PUBLISH HER DEBUT & BESTSELLING NOVEL UNTIL SHE WAS 53.

Stephanie Young was a well-known _New York_ magazine

writer and editor. During the course of close to thirty years, she worked her way through the publishing ranks of more than six major publications—from transcriptionist at _Mademoiselle_ to columnist at _Glamour_, and then as health and fitness director at both _Self_ and _More_. During her career in publishing, she was a pioneer for the writing on women's health that is now so abundant in modern media. And then, in 2007, at the age of 53, Stephanie left the publishing world behind and embarked on a new journey—entering medical school and pursuing a career as a doctor. Today, at age 60, Stephanie is in the midst of applying for residency positions and beginning her career as a medical doctor.

Lisa: At the age of 53, you decided to apply to medical school and become a doctor. What was that moment like for you when you realized you needed to make a shift in your life?

Stephanie: I was with my best friend from sixth grade. She lives in California and I live in New York, but she was on a business trip to New York and we went for a walk. As we walked through Central Park, she was telling me that her company brought in a life coach to meet with her team. The coach asked them, "If money was not a concern and failure was not a concern, what would you do with your life?" And my friend expressed that she was disappointed because she couldn't come up with an answer. Then she turned to me and asked me, "Would you have had a good answer?" And I turned back to her and said, "Oh yes, of course, I'd quit my job and I'd go back to medical school and I'd become a doctor."

And we both just looked at each other. I said, "Oh my God, that's what I have to do." It was not premeditated. It was just this spontaneous expression of what I really wanted. And she said, "Yes, that's what you have to do." And I said, "Okay, okay." What I didn't say immediately was, "Yes, you're right! I'm going to go home and apply to medical schools today!" I was thinking, _Whoa, this is intense. I have to go home and think about this._

Lisa: So then what happened?

Stephanie: I go home, and thank God for the Internet. I typed in something like "prerequisites for medical school" and stuff came up, and then I typed something like "post-graduate premedical education" and all these courses showed up. And I realized after reading all the information that I didn't need to go back to college again. I just had to take calculus. At

the time, I worked on 42nd Street, and I had to get up to Columbia to take the class, on 116th Street on the west side, at four o'clock while I was working a full-time job. I had to leave by quarter of four and the class started at 4:15, which was nerve-wracking. About four weeks into it, my editor comes around and says, "I noticed you're not around as much in the afternoon," and I said, "Yeah." And she said, "Why is that?" And I said, "I have to come clean, I'm taking a calculus class." And she said, "Why the hell are you doing that?" I said, "I want to go to medical school and I have to take this class and I have to leave every day to get there." She was over 40 herself, and her reaction was actually fabulous. She said, "So you can stop playing Dr. Young at the office and actually be Dr. Young?" She got it. Every-one would come to me with their problems and I'd say *do this.* And they'd say, "Are you a doctor?" And I'd say, "No. I only play one in the office."

After I passed calculus, I went to my editor and I said, "Okay, I passed, and I have to quit." And she was so understanding and so sup-portive, and that really helped me.

Lisa: Other things in your life were changing then, too.

Stephanie: Yes, I realized that my marriage wasn't really working. When I went home and told my husband (now my *was-band*) that I was thinking of doing this, his response was, "Well, you didn't ask me." And when he said that, I thought, *Wow, I understand now.* At that moment I understood I had to get out of that

relationship. And I said, "I thought you would support me because I found something that I know will make me happy." And he said, "Well, you didn't ask me." And I thought, *I don't have to ask somebody if I can do this to make myself happy. No, I have to go by my gut.* And so I had to accept that my twenty-five-year marriage was at an end, which was immensely difficult for me. I'd always imagined myself married.

Lisa: When you began telling people about your plans, how did they react?

Stephanie: I've kept every single email from the people that I worked with—writers I worked with, doctors I worked with, other professionals I worked with—who were just so overwhelmingly supportive. "Wow, I can't say it's going to be easy, but go for it," they said. "Wow, I'm so proud of you." There was just so much support, and I pull that folder out a lot and just look at it. I often go back to that initial groundswell of support and that has really sustained me.

Lisa: Did you encounter any difficulty in the application process because of your age?

Stephanie: Well, none of the American med-ical schools I applied to accepted me. I was told off the record by an admissions person at a prominent medical school that I was "far too old." So I applied to school in the Caribbean. I was accepted by Ross University, and I packed up my life and moved to Dominica (the island between Martinique and Guadalupe). It is a third world country, and despite being a die-hard New Yorker for twenty years, I loved it.

PART OF MY SUCCESS
IS UNDERSTANDING
WHAt I DON'T KNOW...
At the SAME tIME, At
tHIS POINt IN MY LIFE,
I'M NOt AFRAID tO BE
VULNERABLE AND
ASK FOR HELP WHEN I
DON'T KNOW SOMETHING.
tHAt ALSO WORKS IN
MY FAVOR.

STEPHANIE
YOUNG

Lisa: In what ways do you think your experience entering medical school and becoming a doctor in your 60s is different than it would've been had you started this path in your 20s?

Stephanie: My age is kind of not present and present. When I'm sitting in a group in a lecture or asking questions, I'm the student, like everybody else who's 24 years old. Or, I'm in a study group and wrestling over a concept just like everyone else. And then every once in a while, I bump against the sliding glass door, which is like, *Oh wait, you're not going to go out with us and play flip cup or beer pong, because you don't do that.* Students will come up to me and say, "Wow, after the first day of lecture, the professor already knows who you are." And I say to them that's because I'm the professor's age.

The thing I bring is my life experience, and that works for and against me. For example, I have this fancy-pants calculator that I bought because it was a requirement. I had no idea how to use it, so I turned to the person next to me and I said, "I have no idea how to use this. Can you show me?" Part of my success is understanding what I don't know. For example, that I'm behind when it comes to intuitively understanding technology. But, at the same time, at this point in my life I'm not afraid to be vulnerable and ask for help when I don't know something. That also works in my favor.

Lisa: That must feel really exciting to be learning so many new things.

Stephanie: It is both exhilarating and terrifying. It's like I took a leap off a cliff, and the free fall is exhilarating, and not knowing where you're landing is terrifying—no matter how hard it's been, no matter what the challenge is.

Lisa: What advice would you give to women over 40 who want to do something new—and I mean like *big new*, like the change you made.

Stephanie: The difficulty a lot of women have is finding the thing they want to do. I talk to a lot of women who say, "How did you find it? I want to make a big change, too." There's a lot of yearning. So if you want to make a change, just be open, and be open to unexpected directions. I mean, a conversation with a friend, when you're just walking around chewing the fat—it changed my life. What worked for me was that intuitive moment when I realized what I have is this amazing opportunity. You have to be open to the universe putting an idea in your lap. I could've easily said to my friend, "Oh yeah, I would've gone to medical school, but I can't do that now because I'm too old." It's just needing to be open to it and understanding that, without sounding too woo-woo, the universe is going to send you a message and it's going to be a wake-up call. Just be ready.

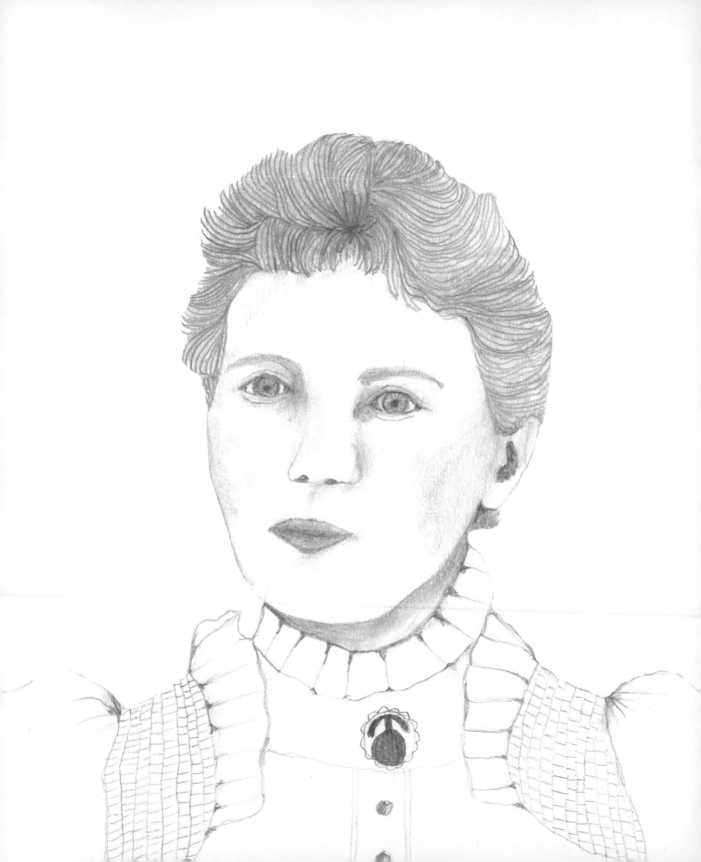

Laura Ingalls Wilder did not publish her writing about Ma, Pa, and the little house on the prairie until she was well into her 60s, a fact little known to many of her adoring fans. The stories of her American pioneer childhood are among the most well known and beloved in the genre of children's literature in the United States.

Laura Ingalls was born in 1867 in Pepin, Wisconsin. As she would later document in her book series, her family moved frequently throughout the Midwest, settling for short periods in Missouri, Kansas, Minnesota, and South Dakota. At just 15 years old, while living in South Dakota, she began teaching at a one-room schoolhouse, although she never graduated from high school herself. In 1885, at the age of 18, Laura married Almanzo Wilder and quit teaching to raise children and help Almanzo work the farm. The family later purchased land in Mansfield, Missouri, ultimately establishing a prosperous dairy, poultry, and fruit farm.

In the 1920s, Laura began the process of writing a memoir of her childhood, which included stories of survival in the face of cold and lack of food and other harsh difficulties of pioneer life. She eventually shared it with her daughter Rose, who had become a newspaper reporter. Rose encouraged her to publish the memoir, and over many years that followed, Rose helped her mother reshape the narrative for a younger audience. *Little House in the Big Woods*, her first book, was published in 1932 when Laura was 65 years old.

The book was an immediate hit with readers young and old, and Laura continued her prolific writing career into her 70s to complete a series of seven beloved novels based on her life, the last published in 1943 when Laura was 76 years old. She kept an active correspondence with her fans until her death in 1957 at age 90. From 1974 to 1982, a popular television show based on Laura Ingalls Wilder's books brought her amazing stories of pioneer life to the screen, delighting viewers and spawning a new generation of *Little House* enthusiasts.

THE UNEXPECTED, EXHILARATING FREEDOM OF BEING SINGLE AT 41

by

Glynnis MacNicol

This past September, on the eve of my 41st birthday, I was propositioned by a 20-year-old cowboy I barely knew. "Do you want to have sex?" he said to me, with a directness and confidence that—even though we were in the Bighorn Mountains of Wyoming—would do a New Yorker proud.

Standing alone in the darkness with an unfamiliar man could have been unnerving, but in this instance it was mostly amusing, even heartening. I had been living on a dude ranch for the month of August, disengaging from my life as much as possible after a year of intense highs and lows, and the entire place radiated openness, adventure, and anticipation. Even in the dark, this young man showed the swagger of all the wranglers here, men who wear their jeans exactly the way Levi must have dreamed they should be worn. And yet, despite the cinematic quality of the scene, I turned him down. (Him: "Really?") Partly because I had to be up in two hours to drive to the airport and still hadn't packed. But also because over the past year I'd regularly found myself a source of interest to younger men—men traveling the country on motorcycles, ex-marines, graduate students—making this encounter somewhat commonplace. I'd stopped thinking about it as some sort of anomaly, a one-off opportunity I needed to grab or forever lose the chance. I knew what I wanted, and at this moment it was not this.

Had I listened more closely to the tales of some of my unmarried women friends it might not have come as such a surprise that single life after 40 can be full and fantastic and fun. But there's a distinct lack of celebratory role models for single women without children, and that lack creates a void where there should be stories—from a distance, the uncharted space can seem very scary, if not downright deadly. Even as our ideas about women and age slowly begin to advance, 40 remains a metaphorical guillotine, as though your birthday will descend, and boom, all the things you value about yourself (or rather, that you have been taught are valuable) are suddenly, grotesquely hacked away, and you are left shapeless and worthless, or worse, invisible. In the stories we tell ourselves about women's lives, there exists little

evidence of what life after 40 for unmarried women without children is actually like; you'd be forgiven for assuming the "now what?" that comes after no marriage, and no children, is a wasteland devoid of love and opportunity to be endured alone till death.

On one hand, this may not be entirely surprising. The single, economically independent woman is a very recent phenomenon—a woman could not even get her own credit card in this country until 1974—and our stories are still catching up with our reality. On the other hand, the stories we do tell tend to render women beyond their childbearing years culturally invisible. (If marriage and babies can be considered a mark of success for every woman, then only the most exceptional women seem able to remain single and childless and have it counted as a triumph.)

I'm particularly aware of this as my friends walk down more recognizable paths of marriage and motherhood. Which may be why, as I left my 40th birthday behind and sallied forth into the decade ahead, I often felt like some sort of pioneer out to explore and settle new land, overwhelmed by the emptiness and total absence of road signs.

Which, I have to tell you, is pretty fucking exhilarating most of the time.

Here's the thing that has been the most shocking and that no one prepares you for: the freedom. Women today are not taught how to deal with this kind of freedom, any more than women of our mothers' generation were taught to deal with their own money. We enable others' freedom—as home keepers, child-minders—but are rarely rewarded for having our own.

Meanwhile, men, or white men, have been taught nothing but. It's the goddamn ethos of this country: Go West, be free, grow up with the country. As anyone with even a cursory knowledge of American history can tell you, the reality of "Go West" was much different, but the iconography endures. Women, meanwhile, are taught that their value lies in their use to other people: their husbands, their children, or, barring these, society at large. (For so long, implicit in the choice not to have children has been the sense that women are obligated to justify this decision by articulating how they will then devote their lives to otherwise making the world a better place.) They are taught to want to be tied down. Entire media industries and much of the last century's American advertising complex have been built on this premise. We are taught anything else is either a failure or a danger; men get to adventure, women who venture out must be on the run, to their death more often than not.

However, I am now awash in a freedom I did not anticipate and I feel great, which at times has been unnerving. Am I supposed to feel this great? I possess none of the traditionally recognized keys to happiness: no husband, no children. I am alone, a state that I am supposed to have spent my life trying to avoid. There is so much around me that suggests I should be feeling otherwise that at times I second-guess my own contentment. And yet, when people ask me what I do, I'm sometimes tempted to answer, "Whatever I want." This is not a boast—I have financial obligations like everyone else, and only myself to rely on

for meeting them—so much as a statement of fact and a reminder that I belong to the first generation of women for whom this can be a real truth. But it also feels like I've discovered some sort of secret—like, *Oh my God, you guys, it's so great over here and no one wants you to know about it.*

Which is also why I bring up the men. One of the things that happens when you step off the path toward marriage and babies is you step into a much wider, more interesting world of men (or women, as has been the case for a number of friends). Of all ages.

Which is not to say it can't also be really fucking hard to be alone, and sometimes deeply lonely in a soul-shaking sort of way. Inevitably there are the middle-of-the-nights when it is also terrifying. And sometimes it's just plain exhausting. When you are the person free to do what you want, what you often end up doing is taking care of other people with fewer options. More than once in the past year I have crawled home to my empty apartment emotionally gutted and feeling like I'd been run over by a truck, thinking enviably it'd be worth it to be married just to have someone else who is obligated to deal with my family, and also cork the wine and load the dishwasher.

Fortunately, I'm old enough to know that people in marriages, and with children, feel all of these things (and how much worse is it to feel lonely in a relationship, which is something so few people talk about and so many experience) at one time or another. No matter how often we imagine marriage as the solution to women's problems, it is simply another way of living.

It was when I was on a hike in the Bighorns this August that it occurred to me I had through an extreme combination of circumstance and deliberate choices, become the very role model I'd been missing. I was out walking alone in the hills, as I did most every day for a few hours, without a phone and only a general sense of where I was (I always told someone when I was leaving in case I got lost and didn't make it back before dark . . . not a joke), dazzled by the emptiness, hoping to spot one of the coyotes I could hear howling in the early mornings, and vaguely contemplating the strangeness of my current situation. Behind me a line of horses who'd been let out into the hills for the night followed me up and over the rise and down into the valley, as if I'd been their de facto leader. I'm not a person prone to Oprah-like mantras (if I have a mantra at all, it probably involves chocolate and Champagne), but at one point I looked up and thought: *Whoa, I love it out here in the land of 40, unmarried, and no kids.* Or, to quote Lewis and Clark upon sighting the Pacific Ocean: "O! The Joy!"

Glynnis MacNicol is a writer and cofounder of TheLi.st. Her work has appeared in print and online for publications including Elle.com, where she is a contributing writer, the *Guardian*, the *New York Times*, *Forbes*, the *Cut*, the *New York Daily News*, *Marie Claire*, *Capital New York*, the *Daily Beast*, *Mental Floss*, *Outside*, *Maclean's*, and *Medium*.

Minnie Pwerle

, a now well-known Aborigine artist, was near 80 before she picked up a paintbrush, but once she had one in her hand, she filled canvas after canvas with her bold, vibrant strokes of color. In her brief career, she became one of Australia's most celebrated indigenous artists.

Minnie was born in the early part of the twentieth century (estimates vary, but her birthdate was likely between 1910 and 1920) in Utopia, a remote part of the Northern Territory of Australia. As a teen, she had a relationship with a married white man and the two had a daughter, Barbara Weir. The couple was jailed, as interracial relationships were considered a crime, and at age 9, Barbara was taken away from Minnie. She was part of the "stolen generation"—Aboriginal children who were forcibly removed from their families and placed in foster care. Minnie, who spoke little English, believed Barbara to be dead. Minnie went on to marry and have six more children.

In adulthood, Barbara, who had become an established artist, found and reconnected with her mother. On a visit to her daughter's studio in 2000, Minnie picked up a paintbrush and began to create her own canvases, drawing on the traditional body-painting motifs of the Aborigines, but with her own distinct gestural flourish and colorful palette.

Within a year, Minnie had her first solo show of paintings and her work immediately became sought after. Minnie painted prolifically and was known for her vigor—she rose at dawn and worked all day. As the popularity of her work grew, Minnie faced pressure to create. She found comfort and community with her family, encouraging her sisters, also in their 70s and 80s, to collaborate with her on canvases, working together until her death in 2006.

WE ARE GETTI
WE ARE GETTING
ARE GETTING FREE
YOU GET THE W
TRUTH, THEN YO
AND YOU GET
THEN — LOOK

NG OLDER, AND
WISER, AND WE
R. AND WHEN
SDOM AND THE
U GET THE FREEDOM
POWER. AND
OUT. LOOK OUT.
MELISSA ETHERIDGE

Paola Gianturco

ended her thirty-four-year-long successful career in marketing and corporate communications to become a photojournalist—at the age of 55. Prior to pursuing photography, Paola had been a principal at the first women-owned advertising agency in the United States, Hall & Levine, followed by a nine-year stint as an executive vice president at the international agency Saatchi & Saatchi. Since leaving the corporate world behind, Paola has produced five photographic books and has documented the lives of women in fifty-five countries. Her most recent book, *Grandmother Power: A Global Phenomenon*, was awarded the 2013 International Book Award for Multicultural Nonfiction and *Foreword Reviews's* 2012 Women's Studies Book of the Year Award, among other accolades. In 2013, Paola was listed as one of 40 Women to Watch Over 40, and *Women's e-News* named her among 21 Leaders for the 21st Century in 2014. She is currently working on her sixth book.

Lisa: At the age of 55, you decided to take a year off from your career in communications for photography and travel, and then you never went back.

Paola: I had been working in communications for almost thirty-five years, and the last one of those years I had also been teaching, so I was doing essentially two jobs at the same time. And the result of that was three things: One, I was exhausted. Second, I had earned two years' worth of money in one year, and I said to myself, *Whoa, I just bought myself a year.* And third, I had about a million frequent flyer miles and my husband gave me his additional two million. Suddenly I had enough free airline miles to go virtually anywhere in the world, and I could also stay anywhere because they take miles at hotels. I thought, *Why don't I do for one year only what I love most and want*

to learn next? And so I envisioned this as my sabbatical for a year.

I wanted to learn about women in the developing world. This was the year of the Beijing Conference in 1995. I didn't go because I was teaching Women in Leadership, at Stanford, in seminars for the Institute for Research on Women and Gender. Because I was teaching women executives at a summer executive seminar, we were watching the Beijing Conference closely. One big piece of news from that conference was that women from the developing world were spending the money they earned to send their children to school. Men in the developing world had the social prerogative to spend the money they earned on things they wanted to buy—like bicycles, radios, and beer.

This was just at the cusp of people beginning to be interested in microcredit. Nobody was writing about it much, and that was just fascinating to me because I'd lived all of my working life in large corporations, and what I wanted to learn next was about women entrepreneurs starting their own one-woman businesses. And so, that's what I did with one year off, optimistically thinking, *Oh, I can do this in a year.*

Lisa: You go for this year, you take photographs, you research, you interview women, and then at some point you decide, *I'm not going to go back to my job, I'm going to keep doing this.*

Paola: I was driving across the breadbasket of Bolivia, standing in the back of a Toyota pickup truck, shooting the sun going down in this beautiful area full of wheat fields, and suddenly in the warmth of that moment, I thought, *This is the happiest I've ever been, working. I'm not going back.* I mean, I was perfectly happy doing what I'd been doing before, and I was very well compensated for it and very senior—I was executive vice president of what was then the largest advertising agency in the world. I really was not having a middle-age crisis at all. And that was really the turning point.

Lisa: Then you get back home and you want to start writing about what you'd documented. What was that like for you?

Paola: Over the course of the next four years, I learned how to find an agent and publisher and write a book. I had to learn how to get a museum exhibit. I joined the board of The Craft Center, which worked with low-income artisans in seventy-nine countries all over the world, and I became, ultimately, the chairman of that board. And I joined the board of the Association for Women's Rights in Development, so that immersed me completely in the contextual information that shaped the book, essentially.

Lisa: Such a learning curve!

Paola: Yes! I have always loved the idea of doing something I have not done before, and better yet, if it has not been done before. So I am constantly, and have always been my whole life, plunging into the swimming pool, into the deep end, without checking to be sure there's water first.

So, that's the story of that first book, and I always have a file of about fourteen book ideas. And when I looked at the file of fourteen new ideas, the one I thought would be interesting for people to read was the idea of doing a book that documented festivals that celebrate women, of which there turned out to be many. In a world in which women are in many places denigrated and discounted, I decided to do a book on festivals that celebrate women. It took me to fifteen countries.

Lisa: Once you finished *Celebrating Women*, your third book happened somewhat by accident.

Paola: I had been going to Guatemala to do test shoots for all of the books. I spent some time one summer working on a pro bono basis

with a museum in Guatemala that wanted me to document the villages where the weaving traditions were endangered. As it turned out, I had slews of photographs of Guatemala, and the publisher asked if I would like to do a book with those. Since I was already off and running with what I thought would be my third book (something totally different), my husband, David Hill, agreed to write that book to my photographs. And the name of that book was *Viva Colores: A Salute to the Indomitable People of Guatemala.*

Lisa: Your next book focused on some really incredible female leaders.

Paola: Yes, my fourth book was *Women Who Light the Dark.* It is about women who run nonprofit organizations in fifteen countries, who were just superstars, working on the most intractable problems. I was diving deeper into the lives of women in the developing world, which by this time I had begun to understand more than I did initially. Of course, women are facing terrible problems with trafficking and domestic violence and HIV/AIDS, and are also, in the face of these problems, mounting very creative and energetic campaigns to make life better for themselves, their communities, and their families. And I saw these women as heroic. I still do.

Lisa: And then *Grandmother Power* came along.

Paola: *Grandmother Power* was a natural sequel to *Women Who Light the Dark.* It tells the story of a group of grandmothers who were working together to make the world a better place for their grandchildren. While I was working on *Women Who Light the Dark* in Africa, I began noticing a number of grandmothers who were taking care of grandchildren who had been orphaned by AIDS. They were everywhere I was, in Senegal and Cameroon, Kenya and Swaziland, and South Africa. And these were very poor women, who, I noticed, were beginning to form a collaboration to help each other. For example, they were starting community gardens so that they could feed the children. They were helping each other with childcare after school. They were helping each other's grandchildren with homework. And I thought, *The future of this continent rests in the hands of grandmothers.* So that made me wonder what grandmothers are doing in other places, and of course they are doing a great deal, motivated by their intention and passion for making the world better for their grand- children in the face of really difficult problems.

Lisa: What do you think it is about grand- mothers that makes them so powerful?

Paola: First of all, I should say I think power is not unique to grandmothers, because as you can tell, I've been documenting powerful, energetic, visionary women's work all over the world now for twenty years. But what I think is new about older women's activism is that it hasn't happened before. In the sense of polit- ical change and engagement, I experienced internationally a degree of involvement that is really quite new.

In many countries, grandmothers today were part of the activism of the '60s. They know they can change the world because they did. When you think about the changes that happened with gender and racial equality, changing gender roles, racial preconceptions, discrimination, LGBTQ rights—there have been huge changes since the '60s in large part due to student rebellions that occurred then. These are the women who grew up then.

Older women are also healthier than they have ever been in the history of the planet. There are more of us than there have ever been in history. We are living longer. In fact, if you look at the number of new grandmothers every day, it's something like four thousand in the United States alone. And we have had careers, which makes us, essentially, more effective strategically than we've ever been.

Lisa: You started your photography and writing career with little or no formal training when you were 55, and since then you've published five really important books. What advice would you give to women who are considering or embarking on a big change later in life?

Paola: Have courage. I trusted that doors would open that I couldn't anticipate. That was a huge adjustment in attitude for me, because I'd spent so much time working for huge corporations where you set objectives, and then you set strategies, and then you set tactics, and then you got there. There is just no deviation from the path from here to there if you work in that kind of an environment.

So it was a great surprise to discover that as I stepped out of that context and began to follow my own path, my own path was quite a meandering one! Who knew that I would end up making books? I never imagined that when I started out to take what I thought was a sabbatical. So you have to keep your eyes open to the options and the possibilities as they begin to present themselves. I had to learn to watch for them, and then to muster the courage to follow them.

Lisa: Most women your age are not only retired but have been for ten years or so. What inspires you to keep working?

Paola: It never occurred to me to stop. What for? I can't imagine not using what I know and what I can do to try to change the world. It would be a waste. I used to have a recurring nightmare and it was that Baryshnikov came to me and said, "I'm not going to dance anymore," and it just used to make me weep with fear and desperation, because it was such a waste of talent. And that, of course, was a reflection of my own fear. I just can't imagine, if you can still do important work, why you would stop.

ANNE WAY

WAS 77 WHEN SHE COMPLETED A 2,000-MILE SOLO CYCLING TRIP FROM CANTERBURY, ENGLAND, TO EDINBURGH, SCOTLAND.

TAO PORCHON-LYNCH

STARTED TEACHING YOGA AT 53, AND AT 99 SHE IS ONE OF THE OLDEST LIVING YOGA TEACHERS ON THE PLANET.

EVE FLETCHER

WAS AN AMATEUR SURFING STAR AT AGE 83.

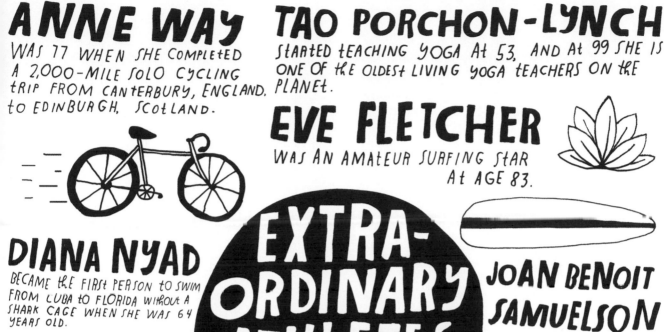

EXTRA-ORDINARY ATHLETES

DIANA NYAD

BECAME THE FIRST PERSON TO SWIM FROM CUBA TO FLORIDA WITHOUT A SHARK CAGE WHEN SHE WAS 64 YEARS OLD.

JOAN BENOIT SAMUELSON

WON THE FIRST WOMEN'S OLYMPIC MARATHON IN 1984. SHE'S CONTINUED TO RUN THROUGHOUT HER LIFE AND AT THE 2008 US OLYMPIC TRIALS, AT THE AGE OF 50, SHE SET A NEW U.S. 50+ RECORD.

DONNA VANO

WAS THE OLDEST PROFESSIONAL SNOWBOARDER AT AGE 61.

ERNESTINE SHEPHERD

IS A 79-YEAR-OLD PROFESSIONAL BODYBUILDER.

ROSALIND SAVAGE

BECAME THE FIRST WOMAN TO ROW SOLO ACROSS THE "BIG THREE," THE ATLANTIC, PACIFIC, AND INDIAN OCEANS, AT AGE 43.

GLADYS BURRILL

RAN HER FIRST MARATHON AT 86 & AT 92 BECAME THE WORLD'S OLDEST WOMAN TO COMPLETE A MARATHON IN 2010, A RECORD SHE HELD UNTIL 2015.

OLGA KOTELKO

TOOK UP TRACK AND FIELD WHEN SHE WAS 77, AND BEFORE HER DEATH WON 34 WORLD RECORDS IN HER AGE GROUP.

HARRIETTE THOMPSON

TOOK UP RUNNING AT AGE 76 AND IS CURRENTLY THE OLDEST WOMAN TO COMPLETE A MARATHON AT 92 YEARS OLD, 65 DAYS.

Julia Child was making fine French cooking accessible to the home cook with her memorable exuberance and extensive knowledge long before celebrity chefs and food show stars were the norm. Her own late entrance to the kitchen—she did not begin cooking in earnest until her late 30s—helped her connect with viewers and share her passion.

Julia was born in 1912 in Pasadena, California. After graduating from college, she had aspirations as a writer and craved experiences beyond her conventional upbringing, but she still hadn't found her calling at the advent of World War II. At 6 feet 2 inches, Julia was disappointed to learn that she was too tall for the Women's Army Corps, so she enlisted in the Office of Strategic Services (OSS) and was stationed overseas. In Ceylon, she met another OSS employee, Paul Child, who would become not just her husband but also her manager, photographer, proofreader, illustrator, and greatest cheerleader.

Julia's path to becoming an icon of cuisine began when the State Department gave Paul a placement in France and she ate the first of many transformative French meals. Raised in a privileged environment where cookery was left to the help, Julia set about learning to cook, taking classes at the famous Cordon Bleu and discovering what would become her life's work. Julia wrote to her sister-in-law: "Really, the more I cook the more I like to cook. To think it has taken me 40 yrs. to find my true passion (cat and husb. excepted)." She started a cooking school and began collaborating with Simca Beck to tailor French recipes for American audiences. Meticulously researched and rejected multiple times by publishers, *Mastering the Art of French Cooking* took ten years to complete.

By the time her labor of love was published, Julia was entering her 50s and Paul had retired. After audiences were charmed by a television appearance she made to promote the book, she was offered her own show, *The French Chef*. Her fluttering voice and occasional spills made her seem affable and ever-human to her audience, but she prepared tirelessly for her shows, putting in hours of research and practice to ensure the best techniques were represented. Julia continued to write cookbooks and produce and star in a series of television shows, winning a Peabody and multiple Emmys, and actively working nearly until her death in 2004 at the age of 92.

TRUE ROOTS

by

Ronnie Citron-Fink

As I took a seat beside my colleagues at a business meeting in Washington, D.C., to discuss toxic chemical reform, I could already feel my scalp tighten. The environmental scientist we were listening to began discussing low-level chemical buildup left in our bodies by personal care products. As she rattled off a list of chemicals, I was struck by a profound contradiction in my own life.

I work for a large environmental organization. In three years, I would turn 60. For more than twenty-five years, like many women who care about their appearance, I had joined the ranks of the 75 percent of U.S. women who color their hair. My personal aim for coloring was "natural-looking" hair to complement my natural lifestyle. To achieve this, I spent hours upon hours, and thousands of dollars, attempting to embody the hair color company's slogan, "Hair color unique to you." But who was I kidding? Whatever was unique to me was buried under layers and layers of hair dye.

"Phthalates, parabens, synthetic dyes, stearates . . . We're just beginning to understand how these chemicals compromise long-term health," the science writer intoned.

"Why do we subject our bodies to questionable chemicals?" a young coworker asked, simultaneously wiping off her lipstick.

"People ignore potential risks for convenience, cost, beauty," she replied. "Many of these products promise a fountain of youth."

As an environmental writer, I knew that since World War II more than 80,000 new chemicals have been invented. In the mid-twentieth century, baby boomers sought "happy days" in what DuPont advertised as "Better living through chemistry." It wasn't until Rachel Carson's groundbreaking tome, *Silent Spring*, was published in 1962 that the cautionary principle of preserving what we need to physically survive—and loving what we must protect—was raised.

Most people assume that chemicals in consumer products have been tested and proven safe, but that is not the case. Carson would most likely be shocked to learn that fifty years after her environmental wake-up call we are still dithering with dangerous chemicals. Why? Because we work on the assumption that something being on the market means it has been

cleared or vetted in some way, when in fact the overwhelming majority of chemicals—and particularly those in beauty products—have never been independently tested for safety at all.

The U.S. Food and Drug Administration (FDA) "regulates" the safety of makeup, moisturizers, cleansers, nail polish, and hair dyes. But according to its own website, "the FDA does not have the legal authority to approve cosmetics before they go on the market," and, further, ". . . companies may use almost any ingredient they choose." Personal care products are a $50 billion industry in the United States, and the cosmetics industry is expected to police itself. We expect our elected officials to pass strong regulations to protect citizens from those who would benefit financially from poisoning us, but those expectations don't always translate to reality.

That Washington meeting was my wake-up call. It was time, I realized, to own up; time to reconcile my knowledge of the consumer toxins underworld—a deep sinkhole masquerading as the fountain of youth—with the reality of my own day-to-day life and what I was doing to my body. I vowed then and there to stop dyeing my signature beauty asset—my long, densely dark hair. As soon as the meeting was over, I dashed from the conference room and made a call to the salon. I could only hope my vanity would find a way to catch up to my deep-seated environmental health beliefs.

Convinced my trusted hairdresser would have a "going gray" strategy in her back pocket, tucked next to her scissors—yet another

chapter in her seemingly endless store of antiaging knowledge—I hit the salon. I was surrounded by the familiar buzz of simmering hair dryers, the concocted chemical scents of hair dyes, and the sight of those creepy circle swatches of artificial hair in various shades—all of it now seeming like the choreography of an old, out-of-step dance.

As I planned how to phrase my cease and desist order, I could see my hairdresser in cape and protective gloves behind a half wall. She was slapping her magic wand into brackish glop in preparation for my root covering.

"Just a trim today, I'd like to stop coloring." I held my breath as she intensely examined my roots. Those roots. The ones that would start growing the minute I walked out the door.

"How would you like to do that?" she asked sweetly, as though I hadn't just thrown a Molotov cocktail into my world of bottled hair color.

Looking around for answers, I noticed the posters on the walls featuring a youth-quake of models in silky, sexy hair, enticing me to embrace "vibrant, fade-resistant color with amazing shine." Where were the stylish and fashionable older women who recently graced the pages of the *New York Times*? The interesting ones described as ". . . women who have fun. [Gray hair] reflects their confidence, their ease with being who they are."

It dawned on me that I had been reading those posters for years—the fact of hair dyeing as

such staring me right in the face—and yet I had never asked to examine the ingredients in my own hair dye. In retrospect, I really wasn't sure how I had managed this level of denial—me, the environmental activist who reads every label like an FBI agent reopening a cold case, poring over it for new clues.

. . . phenylenediaminepersulfateshydrogenper-oxideleadacetate . . .

Now, finally reading the chemical names on the safety data sheet, the boundaries between words bled together in one chaotic blur. In my tunnel vision, I could barely hear my hairdresser's transition plan.

"You have two choices: lowlights or chop. Ronnie. . ." she said with an intimacy that brought on goose bumps, "you're all about your long hair, and gray hair will wash out your complexion. So I suggest we give you a multitonal effect, a few lowlights, and a shorter cut. Or else, you'll look like you've given up."

Women don't *let* their hair go gray. It grows gray. Covering up is an illusion to show we haven't given up. My hairdresser held an outsized role in my beauty, in my life. Listening to her, it was easy to believe that one false step could send me spiraling down an endless stream of bad hair days. Afraid of losing my nerve, I blurted, perhaps a little too loudly, "I'll just let it grow out! Natural. No color." Even over the drone of blow-dryers, heads turned.

I left the salon with just a trim, fueled by my no longer buried conscience. The fact that my notions about beauty and identity could come back to bite me at the cost of my health was suddenly real. I was faced with finding a way to take my high-maintenance mane from darkest brown to "natural" (whatever that was) without the interim help of dyes.

I knew it would only be a matter of days before a skunk line took up residence on my part. Despite my yearning to be chemical-free, the story of my soon-to-depart "youthful looks" raised troubling questions:

Do I check this off as another menopausal moment of surrender? Is there a way to solve the puzzle of how to deal with my roots that will soon shine their moon glow? Can I resist the temptation of a color intervention, a fix . . . a not-so-bad elixir that ultimately will only compel me back to the sink with blackened water circling down the drain? Has the wretched dark slurp already left its compensatory damage on my body? On my planet? And . . . really . . . how old will I look?!?

I was determined not to become a science experiment, but I still batted around these questions for the next two weeks. By then, shiny silver roots mockingly revealed that this process would be nothing short of a meditation in patience. This was not just about waiting for hair to grow. The very public nature of what I was doing upped the ante, revealing sacrifice and acceptance.

"Are you going gray to go greener?" an old friend asked in all seriousness.

"I guess you could say that. The gloppidy concoction slathered on our scalps during the hair coloring process has only two places to go—into our bodies and down the drain—a double environmental whammy. Aren't you worried?"

With my fresh awareness, I was privately hitting my hand against my head, thinking, *Wasn't everyone?*

"My mother is 85. She still gets colored. I think the shade is 'Frivolous Fawn,'" my friend responded.

"I've been doing research," I said, "and more than 5,000 chemicals, some carcinogenic in animals, are used in hair dyes. The scalp has a rich blood supply, and absorbing dye every few weeks must have an impact on our health. Also, the American Cancer Society says that the National Toxicology Program has classified some chemicals that are, or were, used in hair dyes as 'reasonably anticipated to be human carcinogens.'"

"Then how come everyone continues to color?" she asked.

"We know exposure to certain environmental toxins is linked to disease. We're guinea pigs. For what? Beauty."

To that, my friend responded, "To each their own."

After that conversation, I came to suspect I would not be winning any popularity contests if every time a woman asked about my decision I spouted out a chemistry lesson.

Instead, I developed "graydar." I started spotting women in the throes of all stages of the transition to natural hair. I saw them at the supermarket, on the train, on social media, in magazine articles. I came to love these unvarnished women. They were challenging rules, embracing science, and reimagining beauty. And seeing them around me helped me accept my own slow journey.

Going through a hair transition means facing a litany of truths and consequences—straddling the precipices of age, beauty, and health. By flexing my true roots, I joined a formidable sorority of women jumping off the precipice and into public middle age. It used to seem like such a long way down. Not so much anymore, thankfully.

Ronnie Citron-Fink is a writer and the editorial director for the Environmental Defense Fund's Moms Clean Air Force. She is the founder of the blog *Econesting*. Ronnie is working on a new book, *UNCOLOR: Do or Dye Essays.*

THE FLOWERS DON'T KNOW THEY'RE LATE BLOOMERS. THEY'RE RIGHT IN SEASON.

DEBRA EVE

Mary Delany was 72 years old during the Enlightenment era of the eighteenth century when she noticed how a piece of colored paper matched the dropped petal of a geranium, inspiring her to create the first of nearly a thousand cut-paper "mosaicks" of botanical subjects, rendered in exacting detail, pioneering the art of collage as we know it today.

Mary's early life reads like a Jane Austen novel. Born in England in 1700 to an aristocratic family of limited means, she spent her early life with relatives learning music, needlecraft, and dance, hoping to become a lady-in-waiting at court. Instead, she was married off at age 17 to a drunken squire forty-five years her senior who she described in letters as "my jailor." Widowed at 23, but given only a small stipend, she spent the next twenty years savoring her independence and cultivating friendships with Jonathan Swift, Handel, and the Duchess of Portland.

At age 43, she found a second chance at marriage and first chance at love with Patrick Delany, an Irish clergyman. She relocated to Dublin, and the two indulged in their shared passion for plants and botany, tending a lush garden estate together until Patrick's death twenty-five years later. Widowed for a second time at age 68, Mary relied on her friendship with the Duchess of Portland, who had amassed an astonishing collection of natural history specimens and shared Mary's love of fine art and decoration.

While Mary had always been artistic—crafting elegant gowns, needlework, and cut silhouettes—it was the discovery of layering paper to illustrate the exquisite intricacies of flowers that became her medium and true passion. "I have invented a new way of imitating flowers," she wrote to her niece at age 72 with great excitement. She used hand-dyed paper and wallpaper scraps to fashion the illustrations with incredible detail, using hundreds of paper pieces for each picture, creating at once beautiful works of art and accurate botanical documents. Though her eyesight began to fail toward the end of her life, Mary continued her delicate pursuit until her death in 1788.

Cheryl Strayed's famous memoir *Wild: From Lost to Found on the Pacific Crest Trail* was published when she was 43 years old. It took her two and a half years to trace the steps, challenges, and revelations she faced during her three-month, 1,100-mile hike from the Mojave Desert to the Pacific Northwest onto paper—and about two minutes for the finished book to land on the *New York Times* bestseller list. In the months following, Cheryl experienced instant fame—from Oprah's Book Club 2.0 to the film adaptation championed by Reese Witherspoon and Nick Hornby, *Wild* went, well, wild. It is an international bestseller and a recipient of the Barnes & Noble Discover Award and the Oregon Book Award. Cheryl is also the author of the *New York Times* bestsellers *Tiny Beautiful Things* and *Brave Enough*. Her first novel, *Torch*, was published in 2007. Her essays have been published in the *New York Times Magazine*, the *Washington Post*, *Vogue*, and *Tin House*, among others, and her work has been selected three times for inclusion in the *The Best American Essays*. She anonymously authored The Rumpus's popular Dear Sugar advice column from 2010 to 2012, for which she now cohosts a podcast. She currently lives and writes in Portland, Oregon.

Lisa: You worked for many years at writing, and it wasn't until just a few short years ago, in your early 40s, you published the book that made you a household name. I encounter a lot of young artists who imagine that if they just concoct some magical formula they can have "instant success." How would you describe the role of purpose, work, and patience in your own journey?

Cheryl: I was a successful writer long before *Wild* was published. What happened with *Wild* wasn't "success." It was crazy lightning striking. I'm always taken aback when people imply that I achieved success in my 40s. In fact, I had a pretty steady upward career trajectory

as a writer, and all of that came about because, as you say, I showed up each day to do the work. I began publishing in my 20s. By the time I was in my early 30s I had won many awards and grants, and was publishing in respected magazines, and I'd earned my MFA in creative writing. In my mid-30s I sold my first novel to a major publisher and it was broadly reviewed and sold well. Meanwhile, I was continuing to publish essays in prominent places and I was also teaching writing. I was known in the literary community. Then *Wild* happened and with that came fame and a much broader international audience. It was astounding and glorious, but it didn't, for me, mark the beginning of the sense that I'd

OUR POWER IS ABOUT HOW WE LIVE OUR LIVES. START LIVING IT.

CHERYL STRAYED

arrived as a writer. I was already there and I'm still here—working my tail off. That's the magic formula: work.

Lisa: One of the most life-changing lessons I've learned over the past ten years is the power of embracing *all* of my life experience, and this is something you write about as well. Why is this idea of owning and learning to love all of your experience (even the stuff that makes us cringe or that would normally make us feel shame), why is it so important?

Cheryl: I've long believed our mistakes and failures teach us as much as our victories and successes. When you acknowledge the full spectrum of your possibility—as both someone who can be great and as someone who is sometimes not so great—you can bring the full force of your humanity to everything you do.

Lisa: What for you is the best part of getting older?

Cheryl: Feeling more secure about who I am. Feeling stronger about being okay with disappointing people. Putting up less of a facade. Being gentler with myself and others, too.

Lisa: What do you think is the relationship between forgiveness and the ability to age joyfully?

Cheryl: I've written about forgiveness a lot and it all pretty much boils down to the fact that when you can't forgive people who have harmed you (or forgive yourself for the harm you've done to others) you stay locked in that

struggle. Forgiveness is, to me, really acceptance. Accepting that what's true is true. It's saying, this is the way it was and onward we go.

Lisa: What are the three greatest lessons you've learned in the last ten years?

Cheryl: 1. Saying no is one form of saying yes. 2. Our ideas about famous people are projections of who we are, not a reflection of who they are. 3. Everyone struggles. Everyone hurts. Everyone wants to be told it's all going to be okay.

Lisa: What advice do you have for women who fear getting older?

Cheryl: The fear of getting older is about the false notion that one's power was rooted in the things that youth offers us—namely, beauty. My advice would be to see that for the lie that it always was. Our power is never about how pretty we are. Our power is about how we live our lives. Start living it.

DR. RUTH WESTHEIMER

HAD HER FIRST MOMENTS ON AIR AS A SEX THERAPIST IN HER 50s AND CONTINUED TO WORK FOR DECADES IN THE FIELD OF SEX EDUCATION.

ALEXANDRA DAVID-NÉEL

DISGUISED HERSELF AT AGE 56 AS A PEASANT AND HIKED THROUGH the HIMALAYAS TO BECOME THE FIRST WESTERN WOMAN TO VISIT THE TIBETAN CITY OF LHASA IN 1924.

EXTRA-ORDINARY ADVENTURERS SCIENTISTS & ACTIVISTS

ANNA LEE FISHER

IS THE OLDEST ACTIVE ASTRONAUT AT 67 YEARS OLD.

AGATHA CHRISTIE

TOOK A BREAK FROM HER LIFE AS A WRITER TO BECOME AN ARCHAEOLOGIST, GLOBAL TRAVELER, AND ADVENTURER AT THE AGE OF 40.

COLETTE BOURLIER

WAS AWARDED HER DOCTORATE IN GEOGRAPHY AT THE AGE OF 90, AFTER RECEIVING MARKS OF "HIGH DISTINCTION" ON HER 400-PAGE, HANDWRITTEN THESIS.

MARIA SIBYLLA MERIAN

SAILED FROM AMSTERDAM to SURINAME TO STUDY AND DRAW TROPICAL INSECTS & PLANTS AT AGE 52 IN THE LATE 1600s.

ROSE WILL MONROE

AKA "ROSIE THE RIVETER" ACHIEVED HER LIFELONG DREAM OF FLYING A PLANE IN 1970. SHE WAS 50 YEARS OLD.

MELCHORA AQUINO,

ALSO KNOWN AS THE "GRAND WOMAN OF THE PHILIPPINE REVOLUTION," GAVE REFUGE TO THE SICK AND PROVIDED A MEETING PLACE FOR THE REVOLUTIONARIES WHEN SHE WAS IN HER 80s.

BARBARA HILLARY

BECAME THE FIRST AFRICAN AMERICAN WOMAN TO TRAVEL TO BOTH THE NORTH & SOUTH POLES — AT AGE 75 AND 79, RESPECTIVELY.

Sister Madonna Buder, also known as the "Iron Nun," the "Flying Nun," and "the Mother Superior of Triathlon," is a member of the Sisters for Christian Community in Spokane, Washington. In 2012, at the age of 82, she became the oldest person to complete an Ironman triathlon—that's 2.4 miles of open-water swimming, 112 miles of cycling, and 26.2 miles of running—all within a seventeen-hour time period. She remains the current world-record holder.

Marie Dorothy Buder was born in St. Louis, Missouri, in 1930. At the age of 23 and against the wishes of her family, she made her vows to the Catholic Church and became a nun at Sisters of the Good Shepherd in St. Louis. She served there until the order sent her to Spokane in the early 1970s. It was then that she left the convent to join the Sisters for Christian Community, a nontraditional order.

At 48, with encouragement from a priest who detailed the activity's benefits for mind, body, and spirit, Sister Madonna began running. Just five weeks after her training began, she ran her first race—the Lilac Bloomsday Run in Spokane. She continued to train and completed her first triathlon in Banbridge, Ireland, at the age of 52: the course was hilly, the water was freezing, and she rode the cycle portion on a secondhand men's bike she'd bought at a police auction. Since that race in 1982, she was hooked, and has completed more than forty marathons and around 360 triathlons, including forty-five Ironman distances.

In the course of her career as a triathlete, she has pioneered participation in several Ironman age groups, opening the race to women in their 60s, 70s, and 80s. At age 75, she was the oldest woman to complete an Ironman race, a record she proceeded to break the next year at 76 and again at age 79. She was determined to open the women's 80-plus age group, and she did at Ironman Canada in 2012, in the same race that she captured the world record and became the oldest person to ever complete an Ironman. Sister Madonna was inducted into the USA Triathlon Hall of Fame in 2014.

Zoe Ghahremani left behind a two-decade-long career in dentistry to become a full-time writer at the age of 50. In 2000, she sold her practice, quit her teaching job, and relocated from Chicago to San Diego. She is now the author of two novels, *Sky of Red Poppies*, winner of the 2012 One Book, One San Diego Award, and *Moon Daughter*, which won Best Fiction in the 2015 San Diego Book Awards. She is also the first-place recipient of the prestigious California Stories award, and in 2004, her work was awarded Best Fiction at the Santa Barbara Writers Conference. Born and raised in Iran, Zoe writes in both Persian and English, using fiction as a means to examine the experience of Iranian women. Hundreds of her short stories and articles have appeared in publications in the United States and abroad, and she has spoken at universities nationwide, including Georgetown University, UC Berkeley, and the University of Chicago, among others. She was a columnist for *ZAN* magazine and is currently finishing two new works of fiction.

Lisa: Let's start by talking about your first career as a dentist. You trained as a dentist and practiced dentistry for two decades. You even taught dentistry at Northwestern University. How did you choose that as your first career?

Zoe: I grew up in Iran, where a dictatorship ruled the family, so being a good student, your choices would be in medicine, dentistry, engineering, and things like that. I loved literature. I've been a writer all my life, ever since grade school. And I wanted to be a writer, but my family wouldn't even hear about it, because: "What's literature going to do for you? You'll be a teacher at the most. Who wants to be a teacher? You can be a doctor." So I really was given no choice. The best I could do was to reduce my sentence from medicine to dentistry.

When I moved to the U.S. to be married (I had met my husband in London) they told me, "If you want to practice, you have to get your American boards." It took me two more years to get my American boards, and by then, I had already worked so hard that I had to get some benefit from practicing. So I practiced for years.

And then one day when I was 50 years old, I was driving to my practice (and I had a very successful practice, I had about five thousand active patients), I was listening to public radio, WBEZ in Chicago, and somebody quoted the famous saying, "If you have always wanted to do something, do it." This is a cliché, but I felt like I was hit with a ton of bricks. *Why am I going to my dental office?* Because at that same time, I had a tape recorder hanging from

my rearview mirror, and during my commute, I would dictate *Sky of Red Poppies*, my first novel, to it so my secretary could transcribe it. Now I'm thinking, *What are you doing? You no longer have to be a dentist!* And so that was the day I put my practice up for sale.

Lisa: Literally, it happened the same day?

Zoe: The same day I ran the ad to sell my practice. My secretary thought something must have hit me and knocked me out of my mind, because I walked into the waiting room, gave her the tape from the day before, and said, "Please type this, but also while you're at it, why don't you type an ad to put in a magazine for selling the practice." She said, "What happened, doctor? What happened?!" I said, "Nothing, I've just decided."

Lisa: You said you've always been a writer and that you've loved writing since you were a little girl.

Zoe: Yes. And you know what is interesting? Not once, not once, in any of my dreams have I ever been a dentist. Can you believe that? Not once. So that tells you how much I was not a dentist at heart.

I was the youngest of seven children in my family, and I'd lost my parents at a young age. In the Middle East, you have to respect your older siblings. If they tell you to shut up, you can't say, "Shut up, yourself." You have to just be quiet about it. So I'd write my reactions in my diary. But the fact is that as a child, everyone knew that I had poetry and writing in me.

In junior high, I wrote a novel (they were always dark, dark stories) and my teacher loved it so much that every literature class would end ten minutes early so I could read episodes of my novel to the class.

Later, I wrote another novel, too. Unfortunately, both of those manuscripts are now lost. Because in those days, I'd write by hand and I had just one copy, so if that got misplaced, that was the end of that. And actually, the one copy of the story I had written about a girl who was mute, a friend did the calligraphy for it, and my classmates still remember the story. So I always got great encouragement from my literature teachers, and I never gave up.

My family didn't want me to be a writer, so I would write short stories for a magazine under a pseudonym. I called myself "Lonely Bird," and very few people knew that was me. Some of my work gained popularity. My poetry won me prizes and all that, but whenever I brought up the question of literature studies, the answer was an absolute no. Now that I'm a parent, I think part of the reason might have been that my poems and stories were so dark, so sad, that my family didn't want to push me in that direction. They wanted me to go in the opposite direction and face the realities of life. I'm hoping that was part of their reason.

Lisa: Now that you are older, how do you feel?

Zoe: I have started living! When people ask me how old I am, I say I am 16. Because I have really started to live ever since my first book was published in 2000.

Lisa: Your writing focuses on Iranian culture and history, with women's experience as the lens. How does your experience as an immigrant influence your writing?

Zoe: My story as an immigrant is slightly different from most others, or at least most Iranian immigrants that you hear about. I moved here years before the Islamic revolution and the changes that followed. When I lived there, everyone was finishing their education abroad and going back to Iran for all the good jobs. I came here to be married, and the biggest negative point in that marriage was that I would not live in Iran. So immigration was this huge adjustment and a favor I had done for my husband, to move where he wanted to live.

The positive part was the new way of life—the purity of it. Because when you live abroad, you don't see any of that. You see Americans as pushy people who only care about money, and nothing is beautiful or natural. And then you come here and see a whole different world. I loved it. I embraced it. And to this day I do. So, immigration had its positive and negative. And another difference was that I didn't have a language barrier or culture shock. I had grown up with mostly European culture—it wasn't as though I had to adjust to the food, language, or the way of life.

But why I write about Iran: Writers always say to write what you know best. The stories that I write about Iran, no one else could write. These are my stories, they are what I know best. So yes, I could write a story about the people of La Jolla, where I live now, and the

characters, the people in my neighborhood, but then many other writers could write them, and even better.

My readers often say my words take them to a different world. Isn't that what every writer should do? And that's why I focus on issues related to Iran.

Lisa: How are you a different writer now than when you were younger?

Zoe: In many ways. First of all, when I moved here, I wanted to switch from writing in Persian to English. My first book was in Persian, but now I wanted to write in English, especially *Sky of Red Poppies*, because I wrote it mostly with my children in mind. I thought, *Even if no one else reads it, I want to take their hands and take them back to a life and a time that they will never see.* I wrote it for them, and little did I know that so many people would like it. When I moved to La Jolla, the first thing I did was to sign up for creative writing classes at UC San Diego. I soon found out that there's a whole lot of difference between writing in English and writing in Persian: the styles are different, the rules are different.

As I gain experience, my writing is no longer about me. What I wrote as a young person was always personal. As you grow older and you experience the world, it becomes more interesting to listen than to talk. You listen, and you hear new voices. Be it in your past, your present, your future, there are so many voices to hear. They become more important than your own voice. In *Sky of Red Poppies*, I became

the voice of my best friend in high school. *The Moon Daughter* is the voice of a woman I knew. I mean, they are books of fiction and not written exactly as it happened, but the voices are authentic. The book I'm writing right now, *The Basement*, is the voice of the working class.

Lisa: You speak publicly about following your dreams. What advice do you give to older women who are considering a new career or breaking out of the gates to reshape their life in a significant way?

Zoe: Sometimes I am invited to retirement centers, where I meet older audiences who have a lot of questions. You'd be surprised how many writers there are among them! And what I tell them is that it all depends on how you look at it. I could have been looking at my career as a done deal: *I became a dentist, I never became a writer, so my time is done.* And look at me now, four books later, I'm looking at a rather successful career as a happy writer!

And what brought that about was that I decided if I have only one day left, that's how I want to live that one day. We are constantly misled by statistics, and we say, *Okay, that teenager can dream about being this and that, but for me, if I am older, it's done.* But who guarantees that? I ask my audience something I once read in a birthday card: How old would you be if you didn't know how old you are? And I tell them, if you didn't have a birth certificate, and you didn't have any memory, and there were no mirrors, and someone came to you on the street and asked, "How old are you?"—how old would you be? And when they

think about it, they are invariably twenty years younger than what their birth certificate says.

The average life expectancy, especially for women, is between 80 and 90. I tell them, *Some of you are 60, and what are you going to do for the next thirty years? Sit there and brood about what didn't happen, or make it happen now?* There are certain things we can't do. If you want to win a medal in the Olympics and are 70 years old and have never moved a finger, it's not going to happen. But if you are a writer, if you have a dream of traveling, if you are an artist—there is so much you can do. It is so rewarding, to know that you *did* live the moment that you dreamed of.

WE TURN NOT
OLDER WITH
YEARS, BUT
NEWER
EVERY DAY.

EMILY
DICKINSON

GIRL, YOU DON'T KNOW NOTHING

by

Tara Rodden Robinson

"Girl, you don't know nothing."

This was Mama's comment, spoken in her thick Southern drawl, in response to a recent pity party of mine. In her defense, my mom is 83 years old, so her perspective on aging is quite different from my own of 54 years.

My complaints about getting older include declining endurance, the appearance of fine lines around my eyes (not to mention a shockingly deep wrinkle between my eyebrows), and the expense of professional hair coloring services. My mom's litany of aging is more serious: stiff joints and muscle pain, loneliness, and worries about the antics of the stock market with its attendant effects on her savings.

I'm careful not to whine too much in my mom's presence because she casts a predictably dim view of my aging woes in comparison to her own. I don't blame her. I'm sure I sound very much like the bratty teenager that she sometimes still seems to see when she looks my way.

But getting older isn't all bad, for either one of us.

Admittedly, there are some mornings when I watch the younger women in my Ashtanga yoga class and feel like a dried-up old prune (and they're all younger, since I'm the oldest one in the room). But when I hear them complain about dating, I don't mind being the old married lady who just smiles and inwardly celebrates my twenty-plus years with my husband. Even in the company of these little hard-bodied yoginis, I am able to recognize that being older has real benefits and that being in my 50s is a gift that unfolds daily. This is true even while I'm a sweaty mess during my 7 a.m. yoga class, watching the most accomplished star student who, ironically enough, is actually named Star, fold and unfold herself into all sorts of impossible positions.

A *yogini*, if you're not familiar with the word, is the female term for a practitioner of yoga (*yogi* being the masculine form). "A true Yogini is an enlightened woman with exuberant passion, spiritual powers and deep insight," writes Shambhavi Chopra in her book, *Yogini: Unfolding the Goddess Within*. While I'm not sure I can claim enlightenment, I am very willing to state ownership over the three qualities Chopra describes: I am exuberantly

passionate, powerfully spiritual, and I strive for deep insight. All of these gifts have arrived only in the past ten years and are quite clearly fruits of practicing yoga while growing older.

My journey to becoming a yogini actually began in my teens. I'd love to be able to say that I've practiced yoga continuously since I was 16 but, sadly, that's not the case. Growing up in north Louisiana in the mid-'70s, the only yogi anyone knew of was the baseball player, Yogi Berra. Through some miracle, however, I did manage to discover two great teachers who influenced my lifelong desire to practice yoga: B.K.S. Iyengar and Lilias Folan.

If you know much about yoga at all, you probably know who Iyengar is. His book, *Light on Yoga*, is a classic text that has guided thousands of yogis and yoginis in their practice of the eight limbs, or aspects, of yoga. Sadly, my original copy, purchased while I was still in high school, was misplaced years ago, but the influence of reading *Light on Yoga* at such a pivotal time in my development has never been lost. What else can explain how a girl from a redneck, backwater, parochial region of the world managed to turn into a tree-hugging, eclectic bohemian? It was through Iyengar that I discovered vegetarianism, meditation, and ahimsa (the principle of non-harming). If there is anyone to credit for putting me on the path of lifelong environmentalism, it has to be B.K.S. Iyengar.

But let's not forget dear Lilias Folan, who was my more tangible teacher, and who, through her television show, *Lilias, Yoga and You*, introduced me to the poses (more properly called asanas) that I still practice today. I started watching Folan's show when I was 16 and immediately began my homegrown yoga

studio of one. Surprisingly, my straight-laced, Southern Baptist mom was interested in and supportive of this endeavor, even though she'd never heard of yoga. She said the poses were beautiful, and she admired my youthful flexibility. Sadly, she didn't feel inclined to join me on the carpet (no yoga mats back then!). I can't help but wonder how her experience of aging might differ now if she had taken up yoga nearly forty years ago.

Despite my efforts to the contrary, my practice of yoga remained intermittent through my 20s and 30s. Thankfully, I finally arrived in the right environment for serious study in my 40s. After we moved to Oregon, I joined a studio and began learning from accomplished teachers rather than dog-eared books or grainy videos.

I can say with confidence that I'm a true yogini now. And because I'm over 50, I can also tell you that yoga provides one of the best approaches to aging with some kind of grace (even though I regularly topple over during balancing poses). Together, yoga and getting older have catalyzed a season of confidence that I don't think I'd have access to otherwise.

One of the criticisms I heard during my early life was that I was "too emotional." Admittedly, during my teens, I was hell on wheels, but the truth about me is that I am, as Chopra puts it, "exuberantly passionate." Only in the past five years have I come to terms with this aspect of my personality. While I used to see my deeply felt emotions as a liability, I now embrace them as part of my authentic self and express them openly. As a woman in my 50s, I am far more courageous about expressing myself emotionally and intellectually.

People sometimes tell me that I'm brave, and for quite a long time I thought they were mistaken. When someone would tell me that I'd done something courageous, I'd assess my inward feelings and see nothing but sheer terror. Only recently have I come to realize that my feelings of fear while plowing ahead are what actually constitute courage. I've come to believe that this ability to act rationally while terrified is a sign of spiritual power.

Although I was raised in the Southern Baptist church, I parted ways with organized religion when I was 19. Largely, this departure was due to my first husband's influence. He was an atheist and (in hindsight) quite possibly a sociopath. I'd like to say that I don't understand why I married him except that I think I do know: He satisfied my cravings for attention while deftly manipulating my fears of abandonment. Between those two extremes, he emotionally and sexually abused me for nearly ten years.

In the decades after my divorce, I resumed my spiritual path that has led to who I am today: an ardent yogini, committed vegetarian, and devout Roman Catholic. (Bet you didn't see that last one coming, huh?) And yet, here's the truth of it: Whatever deep insight I possess has come through the power I've learned to surrender myself to in my spiritual life. Surrender—with its attendant allowing, releasing, and accepting—is the supreme yoga of growing older.

One of the lessons my mother and I are both learning is that everything changes. Our capacities and faculties alter, shift, freeze, falter. Our pets grow old and die before we do. Many of our friends and family members unhelpfully do the same. These experiences are often exquisitely painful and, even so, abundant with gifts.

One of the great spiritual teachings of yoga is presence: to be fully present, engaged, and yet somehow detached (what some refer to as equanimity). To resist the inevitable means to attempt to exert control over what cannot be controlled. And such resistance is always futile. But with surrender, each change becomes a transaction—something is taken away while another gift is bestowed. In Mama's case, she's received the gift of perspective while I'm opening the present of letting go. Both of us enjoy the gift of each other: I in offering the gift of my caregiving and she in giving me the benefit of her still-enthusiastic baking skills.

Lest I think I've got this all figured out, our lives will always be full of surprises. Crises, like some position we'll be asked to fold ourselves into, will invite us both into discomfort and strained effort. I'm sure that's life's way of reminding me that Mama has been right all along: "Girl, you don't know nothing."

Tara Rodden Robinson, PhD, is the author of *Sexy + Soul-full: A Woman's Guide to Productivity*. She is a coach, an author, and an artist. She founded her coaching practice in 2006 when she left a career in academia. Before that, she enjoyed a lively adventure as a biologist that began in the Costa Rican rain forest.

Carmen Herrera sold her first painting at age 89—after six decades of quiet work creating minimalist geometric abstracts. Her work has since been added to the permanent collections of the Museum of Modern Art and the Tate Modern, overlooked no more.

Carmen was born in Havana, Cuba, in 1915. Her father was the founding editor of *El Mundo* newspaper and her mother was a reporter. She was first interested in art as a child and took lessons, but she chose to pursue an architecture degree instead of an art degree. She eventually left her studies to marry an American English teacher, and the couple moved to New York and then to Paris after World War II. It was in Paris that Carmen began to paint in earnest, inspired by the abstract artists of the Salon des Réalités Nouvelles. The less-is-more painting style that she developed was in defiance of the cultural expectations of the art of a Latin woman, and through it she found her lifelong focus and artistic identity.

The couple moved back to New York, and Carmen continued to paint, further distilling her style to the most essential shapes and colors. "Only my love of the straight line keeps me going," she later shared. Her work was included in several shows over the years but never sold. In 2004, after the death of her husband, a friend brought her work to the attention of an art dealer. Soon after, she experienced her first artistic acclaim and financial rewards. Told that perhaps it was heavenly intervention on the part of her husband that brought her recognition, she replied, "I worked really hard. Maybe it was me." Carmen has continued to work, conceptualizing paintings and executing them with the help of an assistant, long past her 100th birthday.

Fay Westenhofer is a walker in the way that many people are runners, and her routes take her far from her immediate neighborhood in northeast Portland, Oregon. Fay is 74, and in only ten years as a long-distance walker, she has completed eighty-five races, including twenty-one marathons, fifty-two half marathons, and one ultra marathon. She is a dedicated member of the international groups the Marathon Maniacs and the Half Fanatics, meeting their qualification requirement of completing multiple marathons or half marathons in short periods of time—Fay did it by walking three marathons within ninety days. She's 20 pounds lighter than she was when she began walking and has higher bone density, too. Fay describes herself as "sort of retired." She works part-time as a tax consultant at H&R Block when she's not traversing Portland to train for her next race.

Lisa: How did you begin walking long distances?

Fay: About ten years ago, when I was 64, I stepped on the scale and it said 149 pounds, and I didn't want to see 150, because I never, ever had weighed that much. I was over 30 before I weighed 100 pounds. So, I basically looked at that, put my shoes on, and went out for a walk.

Lisa: You have a very small frame, so 150 pounds felt like a lot to you!

Fay: Yes, so I went for a walk and came home and took a nap, and got up the next day and I thought, *Okay, I have to do it again.* And I went for a walk, and I came home and took a nap. The next day and the next I did the same.

Lisa: How did you get into racing and longer distances? That's a whole different level of walking.

Fay: I had begun walking in February, and I had friends who were doing the races and I was curious about what it would be like to participate in them. The very first race that I did was in April of 2007. I did the Race for the Roses, the 5K. I walked it primarily to find out what happens in a race.

Lisa: And then you got hooked?

Fay: Yes! Then in June, I did the Helvetia Half Marathon, which I would not recommend for a first half marathon because it's very hilly! I didn't have the right shoes, ended up with a

nasty blister, and took over four hours, but I kept going. I figured out I needed to get different shoes. And then I walked the Portland Marathon that October, and that was my first marathon.

Lisa: So basically nine months after you began walking, you did your first marathon.

Fay: Yes, and as I was getting ready to do that first marathon, I knew that if I ever did one, I would do at least one more because I wasn't going to be one of those people marking it off my life list and then never doing it again!

Lisa: As you began walking, how did you grow to walk longer and longer distances? What does training look like for you?

Fay: When I first started, I walked only 2 or 3 miles. I was just walking around my neighborhood. The best idea is to work with a training plan. For example, this week you walk 3 miles and next week 4 miles, and the week after that 5 miles, and the week after that drops back to 4 miles. You train by time during the week and distance on the weekends. You always increase the mileage on the weekends for several weeks, and then you drop back mileage a week, and then increase again, and then drop back again, and then increase again, and drop back.

When I first started walking on my own, it was really easy to turn around and go home, and not do the whole distance. At every intersection, you have to make a decision. And after a while, I thought to myself, *There's got to be a better way of dealing with this.*

So I began taking the bus out however far I wanted to walk that day from near my house. Then I'd get off the bus and walk home. So basically I began forcing myself out the distance I wanted to go, and I knew I wasn't going to get on the bus coming back. And after a while, it just became natural to walk that kind of distance.

Lisa: Do people sometimes assume you are a speed walker? Do you ever run?

Fay: I don't do speed walking. It has some specific requirements. I run a little and I walk. I mostly walk, but I run a little bit.

Lisa: Do you ever beat runners in races?

Fay: Yes, sometimes.

Lisa: How has walking changed your life besides being more physically fit?

Fay: The community has become so important to me. Running and walking have different levels of notoriety based on how many races you've done in what period of time. For example, there are the Marathon Maniacs or the Half Fanatics. You may have never met people before a particular race, but they're instantly your friends because they are also wearing the Marathon Maniac shirt. You have an instant connection.

I also became a part of this online group of women runners. These are people who would do anything for me. They're from all over the world. We'd all do anything for each other. They're not like a lot of online women's groups that tend to get catty. When my husband

passed away last year, they took up a collection and made a contribution in his memory, plus sent me a $50 gift card for Portland Running Company, and most of these people I've never met face-to-face.

Lisa: What's the most positive or joyful part of doing this for you? What keeps you getting out there?

Fay: It's almost a walking meditation for me. I'm out there and I'm paying attention to what I'm seeing, I'm paying attention to what I'm hearing. I find myself sometimes going, *Okay, I can hear a bird over here, okay, there's traffic noise, I can hear the planes at the airport, oh I can hear a train, so the wind must be coming from that direction, otherwise I can't hear it from here. I can hear people talking; I can hear animals.* And as I'm walking, I'm paying attention to what people have done with their yards and what flowers are in bloom and what's going on around me. And it's inspired me, in a way, just to see what's going on.

Lisa: To what extent do you think your age has anything to do with this passion of yours? Do you think it happened at the right time in your life, or that it could've happened at any time? If you'd discovered it in your 20s or 30s, do think you might have also pursued it then?

Fay: I think it has most definitely been easier to pursue long-distance walking at my age than it would've been when I was younger, because I am mostly retired, and I have the time. Walking long distances, even if you are fast, takes

a lot of time. I look at some of these people that I know are in their 30s that are training for marathons, and they've got little kids, and they're working a full-time job and I wonder how they manage.

Lisa: What advice would you give older women who are considering taking on a new challenge or exploring a new thing in life, but are maybe hesitant or fearful?

Fay: Just get out and do it! You can do anything you set your mind to, but take your time. You're not going to be fast. You're not going to say today, "Oh, I want to run a marathon or walk a marathon." It's going to take you a good six months to do it, maybe longer, depending on how much of a couch potato you've been. Take your time and enjoy it.

Also, get focused. Focus on what your goal is and figure out why it's important to you. And once you've got that goal and you know why that goal is important to you, it just kind of happens.

Helen Gurley Brown was a copywriter-turned-publisher whose later-in-life career at the helm of *Cosmopolitan* magazine changed notions surrounding sexual and career independence for a generation of younger women. A portrait of longevity, Helen took her post at the age of 43 and remained dedicated to the magazine and its audience for nearly fifty years.

Born on February 18, 1922, in Green Forest, Arkansas, Helen had a young life wrought with challenges—she lost her father at a young age, her mother struggled with depression, and her sister was paralyzed by polio. At 17, she left home to attend Texas State College for Women for three years, followed by a year at Woodbury Business College in Burbank, California. She worked her way through seventeen different Los Angeles offices as a secretary, until 1948, when her employer at the advertising firm Foote, Cone & Belding recognized her writing skills and made her a copywriter. In the ten years that followed, Helen won three Frances Holmes Advertising Copywriters awards for her work.

In 1959, she married Hollywood producer David Brown. Around this time (and quite ironically), she began writing her first book about the pleasures and freedom of singlehood. When *Sex and the Single Girl* became a fast bestseller in 1962, Helen left the world of advertising behind. Instead of copywriting, she dedicated her time to working on her next book, *Sex and the Office* (published in 1964), as well as her nationally syndicated advice column "A Woman Alone." Helen's emphasis on the benefits and freedoms of unmarried life and the idea that women are, in fact, sexual beings garnered her attention and criticism, which led to the next phase of her career.

In 1965, at the age of 43, Helen was named editor in chief of the then-sinking *Cosmopolitan* magazine. With no formal editing experience, Helen drew from the ethos behind her own writings to transform *Cosmopolitan* into the sometimes controversial, overtly sex- and independence-focused young women's magazine we know today. Her work was daring and groundbreaking, both in content and in design. *Cosmo* began and continued to outsell other women's publications throughout the three decades of her leadership. Though her tenure as editor in chief ended in 1997, she continued her work for the magazine as editor of international editions until her death at the age of 90 in 2012.

Della Wells is an artist most known for her evocative paper collages. Since deciding to pursue a career as an artist at the age of 42, Della has exhibited her art both in Europe and throughout the United States, and was featured in Betty-Carol Sellen and Cynthia J. Johanson's *Self Taught, Outsider, and Folk Art: A Guide to American Artists, Locations, and Resources*, among other publications. Drawing inspiration from her own life experience, Della examines the complexities of modern African American women while exploring her own origin story and her mother's mental illness. In addition to collage, she creates colorful pastels, drawings, dolls, and quilts. Not long ago, the Smithsonian Institution purchased three of her pieces. Della recently illustrated her first children's book.

Lisa: I'd like to start with a question about a certain palm reading you had back in your 20s. What did the reading reveal? Has it proven to be true?

Della: This person read my palm and told me that my lifeline is very heavy at the end, and he said I'm gonna go out of this world with a bang. He said, "Everything comes to you later in life."

Lisa: Wow. Did you have any idea at the time what that would mean for you?

Della: No, I didn't, because to be honest with you, I didn't take the person seriously. But I will tell you this, when I was 18 or 19, I used to be involved with this gallery called the Black Aesthetic, but I wasn't an artist. I saw Dr. Margaret Burroughs, and she was in

her 50s at the time, and I remember saying to myself, *I'm going to be like her.*

Lisa: So you kind of knew then?

Della: Yes and no. But when I saw her and heard about her, I thought she was really fantastic.

Lisa: You didn't pursue art seriously until you were 42, and when you started, was it just something you knew you wanted to do? Is there a reason you didn't pursue it earlier in life?

Della: The reason I didn't pursue it earlier in life was that I didn't think of it as a serious career. I planned on doing it as a hobby when I retired. At around the same time that I decided to pursue a career in

art, I was making another career change—I was going to school to become a psychologist. If I hadn't gotten into the arts, I'd have been a psychologist. And at the time, I was at Milwaukee Area Technical College and my advisor said that I needed some humanities classes. She suggested I take an art history class. And I said, "Fine, I know a little bit about art history." I grew up with my parents having a lot of books, and I know a little about art history.

We had to write a paper in the class. I knew everybody was going to write on Picasso, van Gogh, and those types of artists, and I wanted to write on an artist who was African American and who was also from Milwaukee. And so I decided to write on Evelyn Terry. And I remembered Evelyn Terry from the Gallery Toward the Black Aesthetic. So I called her up to do the interview. She remembered me and that I used to draw these weird Picasso-like women having babies, and she's going, "You should be an artist." And I thought, *Yeah, right.*

I then transferred to the University of Wisconsin at Milwaukee. At the time, my major was sociology, I was getting a certificate in women's studies, and my minor was African American studies. I took this class on African American religious studies with Dr. Patrick Bellegarde-Smith, and at around the same time, Evelyn invited me to an exhibition, and everything in it was Haitian influenced, and I heard a voice tell me at that exhibition to go make art. So I told Evelyn I wanted to go make art. I know it sounds crazy.

Lisa: Often the things that cause us to make life changes happen in an instant.

Della: Yes. So I started to go make art, which I had never done before. I mean, I sold a piece at 13 years old, but I was never serious about it. I never thought of it as a career or took it seriously.

So I told Evelyn I'd go to her studio and within two weeks I did three pictures: two pastels and a monoprint. And I never made art like this before in my life, and they turned out! I was shocked that they actually turned out. So later, I shared a studio with Evelyn Terry and another artist. I would go in and work on Fridays. It was very therapeutic for me. And Evelyn would tell me, "This stuff ain't therapeutic." But it was therapeutic, because it happened at a bad time in my life when I was making this career change. I got injured on my job.

Lisa: What was your job before you went back to school?

Della: I was a clerk typist II in charge, and I did data entry and I also maintained the computers. I got injuries from typing too much, and my doctors told me to make a career change. That's why I was going to be a psychologist.

And so Evelyn told me if I got fifty pieces of work, she'd get me a show. I got my first two shows by myself and people started seeing the work and wanting to buy the work, and that was never my intent. I was shocked. My first show I had was at this Café Mélange in Milwaukee, and the second was at the UWM

Women's Resource Center, but that's basically how I got started.

Lisa: You've said that one of the reasons you didn't pursue art earlier in life was that you felt like you didn't really have anything to say when you were younger.

Della: I didn't. And I think it's important for artists to have something to say, and I didn't. When I was younger, to be honest, I didn't want to talk about myself. I didn't have a particularly horrendous childhood, but my mother has schizophrenia and I was always afraid that somebody would discover that my mother was different. And I didn't want to be different.

In middle school and high school, my brothers were all real smart in mathematics and science and I was always the underachiever, and it was kind of funny because even the white kids at school would say they hated my brothers because they knew all the answers and they got straight As. And I didn't want to be different. I think a lot of girls go through this—they don't want to be different. I didn't want people not to like me. And a lot of girls are like that, and so they don't reach their potential.

Lisa: You mentioned you started drawing, you did pastels, you made a monoprint, but now you're known as a collage artist. How did that all start for you, the collage?

Della: Romare Bearden was one of my favorite artists, and I saw this artist named Beverly Nunes Ramsay, and she would do paper sculpture and she would make collages on

paper, and I wanted to try that. And of course, too, I was always interested in repurposing materials. I would always, even as a child, see things differently—I'd see a magazine or paper or found objects and want to make something from them.

What was funny is that I was at this gallery, David Barnett, and I had to do some pieces for Northwest Mutual. I did some pastels, I did two collages for them. And the person who was going in between, she said that she didn't think my collages were my strongest work. But the gallery sold both collages first thing. Then he gave me a solo show, and one of the collages she said wasn't my strongest work—he had six offers!

So I guess the point is, from where I am now in my life, you can't listen to other people, you can't let other people define you, and you will always find a lot of people who will tell you what you should do.

Lisa: You refer to yourself as a storyteller. Tell us a little about the stories you tell with your collages and paintings—themes in your work, and where you draw your inspiration.

Della: I draw my inspiration from life. When I was a little girl, I wanted to be a writer. And the stories I used to write when I was a kid were different from those of other kids. We had to write a story about Christmas. I wrote about Santa Claus having a nervous breakdown. I think I was about 13. We had an assignment in high school, it was about cowboys playing cards and one shot one, and

everybody wrote that they were cheating, and I wrote about a sore loser, that's why he shot him.

Later on, I took a course in creative writing, and we did a collaborative novel. And I didn't want to write what everyone else wanted to write about. They wanted to do a story about a beautiful woman who was an actress; the guy was tall, dark, and handsome and he was a lawyer; and she wanted to find her adopted parents. My friend, who was also in her 30s at the time, we conspired to ruin the story. So her shock was that she was black, and to me that was no big shocker, but when I wrote, I wrote that actually she was born a man, her penis was actually cut off as a baby, and she was raised as a girl. She became this sex symbol, and this other actress found out and was going to blackmail her, and I wrote a masturbation scene that Evelyn Terry actually used in a video she did later.

But it was funny—some younger students got mad, but the instructor said, "Thank God!" She was bored to hell with the story until then. But I always did have an imagination. My mother used to tell me stories, but as I got older, I realized a lot of the stories she told were really part of her schizophrenic mind, and they weren't necessarily true. And when I was a kid I used to make up movies in my head. Full movies—I had actual actors that I had playing the roles. I was also fascinated with Dr. Seuss and fairy tales, because a lot of fairy tales looked nice and sweet, and a lot of my work looks nice and sweet but it actually isn't.

Lisa: Fairy tales are really dark, actually.

Della: Right, right, and really a lot of my work is dark.

Lisa: How do you think your voice is different today than it was twenty years ago when you first started? How have you grown and changed as an artist?

Della: I think experience, life experience, changes your voice. I don't think when I was in my 20s I could have created the same stuff I am creating now. I noticed a lot of the stuff I created in my 40s was reflective of African religion; now in my 60s it's more about my life experience, maybe something that happens in politics. I think growing older—or at least for me—you look at things differently. I know some people perceive me a different way than I actually am.

Lisa: So you think people may perceive you differently than you perceive yourself?

Della: Yes, with the exception of people who really know me, who talk with me and have conversations. But there are other people who perceive me as being distant, not caring. And I think part of it is because people have stereotypes of how they think women *should* act. They think women should be sacrificial lambs, and I'm not going to be a sacrificial lamb, because I want peace and cool.

I noticed that with a lot of women, particularly in my generation, when they get to be in their 40s, 50s, 60s, 70s, people expect them

tAke THE CRITICISM tHAt YOU NEED, DISCARD tHe OtHER CRITICISM, AND DON'T LET THE CRITICISM DEFINE YOU. DON'T LET OTHER PEOPLE DEFINE YOU. YOU CAN DEFINE YOURSELF.

DELLA WELLS

to be caregivers, that you're supposed to be this loving grandmother. A lot of the women I know, they have their own careers, a lot of them have their own businesses, but at the same time they're taking care of family. And I think women get boxed in, like that's supposed to be their prime duty, and you're supposed to sacrifice yourself. And I don't believe in that. I don't think you have to sacrifice yourself.

Lisa: Is that something you've grow into, or have you always been like that?

Della: I've grown into that. Which I think is good; I think it's really healthy. For me, it's healthy; it helps keep me sane. Otherwise, I'd be totally insane.

Lisa: What advice would you give to older women who are considering pursuing a passion, trying something new, or changing their life in a significant way and are doubting themselves?

Della: I'd say first learn what you can about the field that you want to go into. Talk to other people who are successful in the field. Even when I was going to be a psychologist, I talked to other psychologists to find out what it was like. Find the people who are going to support you, and understand there are going to be people out there who are not going to support you.

Also, take the criticism that you need, discard the other criticism, and don't let the criticism define you. Don't let other people define you. You can define yourself. There's always a reason for people to find that you can't do things.

They say, "You're too young, you're too old." You know, Grandma Moses started painting at 60, and I was reading about a couple of other artists who got their first museum show in their 80s and 90s.

I say, go ahead and do it. Life is not over until you have your last breath, and youth does not define you. A lot of the time people define women by their youth, their looks, and so forth—that doesn't define you. Just do it. And believe, and find the people that support you. That's what's important. Find and build a support system.

Angela Morley was not able to live freely as a woman until late in her life. Emboldened with the freedom to be her true self, she went on to create some of the most memorable musical scores of late-twentieth-century television and was the first openly transgender woman to win an Emmy Award.

Angela Morley was born Walter Stott in 1924 in England. She had an early interest in big band music and mastered several instruments before leaving school at age 15 to play saxophone in a dance band. In the 1940s, she began to hone her skills as an arranger, working for BBC radio. She was primarily self-taught but worked steadily in radio, moving on to score films starting in the 1950s. Married and a father of two children, Angela had, nevertheless, endured a lifelong struggle with gender identity. It wasn't until her second marriage in 1970 that she found the support to live her life as a woman. In 1972, at age 48, she had sex reassignment surgery and changed her name to Angela Morley.

Angela withdrew from composing and conducting for a period because she was unsure of the music community's acceptance of her. In 1974, at age 50, she was convinced to supervise the music for the film *The Little Prince*, earning her an Academy Award nomination. She traveled to Los Angeles to attend the Oscars, and felt so welcome and accepted that she decided to relocate to California.

During this period, Angela experienced a renaissance of creativity as she focused on scoring popular television shows of the 1980s, including *Dynasty*, *Dallas*, and *Wonder Woman*, and was nominated for multiple Emmy Awards. She also collaborated, often uncredited, with composer John Williams, making significant contributions to film scores, including the iconic *Star Wars* theme. In the final years of her life, Angela retired to Arizona with her wife, passing away in 2009.

WHEN THEY ARRIVED

by

Shauna James Ahern

My pajamas have handprints of banana smooshed onto the thighs. I can barely open my eyes while I'm waiting for the coffee to brew. The 2-year-old—awake since 5:30 and up twice in the night—is pulling on my shirt, asking for Elmo. I grab my phone to load up kids YouTube—screen time before Mama gets her coffee doesn't count toward the total—and see a reminder flash on the home screen: 50th birthday five months away. Start planning the party!

I am 49 years old. I have a 7-year-old daughter and a just-turned 2-year-old son. And every day, at some point—usually before my second cup of coffee—I breathe a big sigh and think, "It's possible there's a biological reason I'm not supposed to have small children at my age."

None of this was by accident. My husband and I chose this. You can have a surprise baby easily at 25 and sometimes at 35 but rarely at 45. These are children we willed into our lives. Danny and I met when I was 39 and he was 37, after a lifetime of awkward relationships and missed chances. The ones that didn't work cut a bigger and bigger hole in our hearts. I thought I would never get married—I was planning my 40th birthday party as the "I'm

marrying myself party!" It turned into a "Meet the Danny" party instead. There's something especially sweet about finding the love of your life when you're on the brink of 40. None of the clichés and traps of young love line up with the love we had. We forged our own way and fell into each other's rhythms right away. Two months after we met, he asked me to marry him. Two years later, just before I turned 42, our daughter Lucy was born.

Her precipitous fall into the sterile beeping world of the ICU the first two weeks of her life forged us as parents. We'll never forget holding hands over her Isolette, reminding her to breathe. Her nine-hour surgery at nine months old, to build her a new skull, was only endurable because we had experienced that land of unknowing together. Somehow, we crawled through the next four months, when she woke up every hour on the hour, crying, too scared to go back to sleep. We moved like zombies through our days, trying to figure out how to do our work (he as a chef, me editing our first cookbook) when we were just so tired. Somehow, the time passed, in giggles and discoveries through wide-open eyes. Slowly, time passed.

And through all that, we still wanted another child. Lucy brought a new light into our world. We wanted another light to reflect with hers. I adore my brother, one of my best friends in the world. Danny's four older siblings are the bedrock of his life. Since we were already older parents, we wanted Lucy to have a sibling, someone else to know her story.

So we tried for another. And tried. And tried. The trying was fun. The failing was not. Our doctor told us the odds were long anyway—by this time I was 43, way past the Advanced Maternal Age stamped on my charts at the gynecologist's office. We were into the place of thin possibility now. Within the year, we decided to drop the striving and adopt a child.

The next time you hear a well-meaning person try to console a woman who can't have a child biologically by saying, "Oh, but you can always adopt!"—*please tell her to stop*. Adoption is anything but easy. It's first a search for the right agency, then a pile of paperwork, then home studies and inspections. And then it's waiting. And more waiting. And thousands and thousands of dollars. And if you find, as we did, after two years of waiting, that the agency you chose wasn't ever really right for you, you start again, and spend more thousands and thousands of dollars. And wait some more.

Our son arrived when I was 47, three and a half years after we decided we would "just adopt." His birth was one of the most joyful experiences of our lives. And one of the most deeply moving and sad, as well, since I sat with his

birth mother and her loss for three days after he was born. Maybe that's one of the gifts of being an older mother—I never worried about who the "real" mother was. I know I am my son's mother, loving him fiercely, but lightly and kindly, too. He adores me, Danny, and his sister with a devoted sweetness I've rarely seen. And he has another mother, too, one he might know more and more as he grows older. Since I am a full twenty-five years older than his birth mother, he might come to rely on the relationship with her in a different way as I grow older. I don't know yet. It's only speculation right now. But it gives me hope for his future, that he'll have more family.

When my son turns 22, I will be about to turn 70. Make no mistake—I intend to be here. I'm planning on dancing at his college graduation in a bright red dress. I'm not going to stop moving these next twenty years, since he never stops moving. There might be times when my creaky knees protest against kneeling on the floor to zoom trucks around an imagined track with him, but I do it. The exhaustion of sleep deprivation seems to affect me more powerfully than it did when his sister didn't sleep six years ago. (Then again, thanks to perimenopause, I'm battling insomnia often, so I might as well get up when he needs consoling.) But he's a better sleeper than she is, so it's more sporadic. And maybe we do quieter things in the morning together. I've relaxed my stress about morning video time—activated by a culture that screams that any screen time is terrible for a child—and remember again just how many episodes of *The Brady Bunch* and *Laverne &*

Shirley I watched as a kid. I turned out okay. He will, too.

That might be the greatest gift I can give my children as an older parent. I don't think of them as mine, an extension of my ego. I'm not trying to perfect them. I don't want to do all the "right things," like make sure they never eat junk food (Cheetos at the emergency room can be a real gift) or get great grades in everything (heck, if they get As in the subjects they love and Cs in the ones that leave them a little cold, I'll be fine with that) or prevent them from falling on the playground. Breaking a leg can be a rite of childhood passage. I'd rather they run hard and fall than stay safe all the time.

And since I'm an older parent, I know that I might not ever meet their children. That pains me. But it also reminds me to encourage their independence, to be all right in the world without their mom solving their every problem. Life is short. I'd like them to be each other's best friends. And their own.

There are conversations with my daughter, long and important, that happen every day, about tensions with friends and doing what is right, about not expecting to be perfect, and how vital it is to keep doing what makes you deeply happy. (My son and I talk more about trucks and helicopters at the moment, but those talks are coming soon.) If my children had come into my life when I was in my 20s or 30s, I might have had more energy. But I wouldn't have had the wisdom of living another decade or two. Mostly, I tell them this: I love you. And everything passes. You'll be okay.

At nearly 50, I finally know this for myself: everything passes. I will be okay. These children are gifts, exactly when they arrived.

However, I wouldn't mind another cup of coffee.

Shauna James Ahern is the author of the much-loved food website *Gluten-Free Girl*, a food memoir, and three cookbooks, including the James Beard Award–winning *Gluten-Free Girl Every Day*. Her work has been published or recognized by the *New York Times*, *Gourmet*, *Bon Appétit*, the *Guardian*, the *Washington Post*, and the Food Network, among others.

Eva Zeisel resurrected her design career when she was in her 80s—after twenty years away from the design world. The world-renowned ceramic and industrial designer returned to creating new forms in her distinctive style and continuing a lifetime of meeting challenges with ingenuity and perseverance.

Born Eva Striker in 1906 in Budapest, Eva began studying painting at 17. Encouraged by her feminist mother to learn a trade, she left school to apprentice with a potter. She graduated to the journeyman level and became the first woman admitted to the local potter's guild. Eva developed a sensuous, biomorphic form to her pottery, her flowing lines a reaction to the angular modernism of the times. Ever curious, Eva moved to Russia in 1932 and became an artistic director for the Communist government.

In 1936, the course of her life changed dramatically when the Stalinist regime falsely accused her of an assassination plot. She was imprisoned for sixteen months, most of the time in solitary confinement, before she was released without explanation. Eva reunited with and married Hans Zeisel, and the couple fled Europe for New York in 1938.

Eva began working at Pratt Institute, creating the department of ceramic arts and industrial design. In 1946, she designed a collection of unadorned porcelain pottery for the Museum of Modern Art, the museum's first one-woman exhibition. By the 1960s, however, Eva had stepped away from the pottery studio and instead focused her attentions solely on scholarly writing and antiwar activism for the next twenty years.

A trip to her native Hungary when she was in her late 70s got her creative juices flowing again, and she returned in full force to the world of design, creating glassware, rugs, lighting, and furniture in addition to new takes on her traditional pottery designs. In 2005, she was awarded the National Design Award for Lifetime Achievement by the Cooper Hewitt, Smithsonian Design Museum in New York. She enjoyed the renewed interest in her work immensely and worked industriously until her death in 2011 at age 105.

Ilona Royce Smithkin is 95 years old. She is an active impressionist painter and art teacher, and a late-in-life fashionista and "Eyelash Cabaret" performer. During her lifelong career as an artist, she traveled across the country teaching painting to students of all ages and experience levels, hosted three instructional series on PBS, and made the famous paperback portrait of Ayn Rand. In 2010, photographer Ari Seth Cohen met Ilona (who, of course, was looking exquisite in a turquoise and lime green ensemble) on the sidewalk in New York's West Village. He took her photograph for his blog, *Advanced Style*, in which he features women over 50 who dress with zest. Ever since, Ilona's fashion sense, right down to her long red eyelashes, has garnered her attention from the likes of *New York Magazine*, *Time Out New York*, the *Huffington Post*, and others. She continues to inspire with her passion, openness, and enjoyment for every day—and every little thing—life brings.

Lisa: Ilona, what is your favorite part of the day?

Ilona: Every moment, because I'm alive! I gather all of my energy and do all kinds of things, like when I go and take my baths. Afterward I have ointments, and I take creams all over. I love the smell. I try to enjoy everything I do.

Lisa: You're an artist, fashion icon, and performer. Which came first?

Ilona: All my life I've been an artist, but I had lots of different jobs in order to sustain myself. Because unless you're born rich or have something that makes you special, you just have to muddle along. It's hard to make a living as an artist, as you probably know.

Lisa: Yes, I do! Tell us about being a teacher.

Ilona: I have been teaching art impressionism for forty years. Every year, in the spring and the fall, I went out for two months all over the United States—Arizona, Iowa, South Carolina, North Carolina, Kentucky, Indiana. I mean, you name it, I was all over the place. And I stayed one week in each community, then they'd pick me up for the next community, so I did a lot of all-around teaching.

Lisa: It's been forty years, so you started teaching in your 50s?

Ilona: I think I started in 1969, I believe. I still teach today in New York, but I no longer travel.

Lisa: Do you feel like you're a different person than you were when you were younger?

Ilona: Everybody is a different person according to her experiences, because you learn

while you live. Every day you learn a little something, unless you're not open.

Lisa: How do you feel like you're different now than you were ten years ago?

Ilona: Until recently, I always had a feeling that I was not good enough. I never gave myself credit. Even when I did important things, like illustrating Ayn Rand. Ayn came to me because she liked my style. And she liked it so well that she put it on all her book covers. When you look at book covers of Ayn Rand, you can see my portrait that I did of her. And I painted Tennessee Williams, did you know?

Lisa: Oh, no, I didn't. That's wonderful!

Ilona: I'm the only one who did it. I met him in Key West at a dinner party—I had no idea who he was, but he and I clicked immediately and we laughed a lot. I had a celebration of a portrait I did of a fellow in Key West, and they had an unveiling, and he was invited and he said to our host, Roy, "I never wanted to be painted, but I would like to meet this guy who painted this." And our host said, "Now for one, it's not a guy, it's a girl, and you know her because she's standing next to you." Ha!

Lisa: So when you were younger, you didn't give yourself very much credit, but has that changed now that you're older?

Ilona: I never believed I was good enough. You know, I never gave myself credit. The difference between then and now: I know who I am now. It took me an awfully long time. It was

maybe just ten years ago when I was in my 80s that I found out. But I feel now very full of myself, and I give myself credit for all these years of struggling and all the people I met.

Lisa: You have figured out the secret to a fulfilling life—you're very happy, you enjoy yourself, you feel good. What advice would you give to women who are struggling to find their happiness?

Ilona: Everybody is struggling for something. Some, all they want to do is find a lover. Others want to be very famous. Others want to have a well-paying job. And they might give up when they don't succeed right away. But it takes quite a long time to nourish whatever you want to do with your life.

Also, there are different ways to be happy. If one way doesn't work, try another. I didn't understand this when I was younger. I never knew there were several doors in life. I always thought I have to go straight, the same way I was brought up by my parents. But then I discovered there are lots of doors in life and lots of potential, if you are open.

Lisa: So openness is an important part of being happy?

Ilona: Yes. Look for different ways of finding happiness if something doesn't go well. But don't give up immediately, like many people do nowadays. And open communication is important, too. For example, in their relationships, many people, in the first fight they have they say, "Good-bye, baby," you know? But

THERE ARE DIFFERENT WAYS TO BE HAPPY. IF ONE WAY DOESN'T WORK, TRY ANOTHER. I DIDN'T UNDERSTAND THIS WHEN I WAS YOUNGER. I NEVER KNEW THERE WERE SEVERAL DOORS IN LIFE.

ILONA ROYCE SMITHKIN

you have to work it out, and the best way to work out things is with communication. You talk about it, you're honest about things, you try to find out what is wrong, and then you try to fix it. It's not a one-way street. When you deal with another human being—whether it's a teacher, a lover, or a business partner—I've learned you have to consider that the other person has a different point of view, and it's often not going to be the same as yours! But the essential work is the compromise. And in life you've got to learn how to compromise, to give in. You don't have to give in to everything, but if both people give in a little, you'll find peace.

Anna Arnold Hedgeman, a lifelong advocate for social change, was given a platform for her voice late in her career, allowing her to leave a powerful and lasting impact on the civil rights movement.

Anna was born in 1899 in Marshalltown, Iowa. She and her family were the only African Americans in the small town. The Methodist church, education, and a strong work ethic were the foundations of her childhood. She attended Hamline University in Minnesota, becoming the college's first African American student and graduating with a degree in English. She accepted a position to teach English at the historically black Rust College in Mississippi, where she experienced institutionalized segregation for the first time, galvanizing her lifelong commitment to civil rights. Anna left teaching to serve as a director at the YWCA, relocating to different facilities throughout the East Coast. She married Merritt Hedgeman, an interpreter of African American folk music, in 1936.

Although Anna had always been active in protest activities and civil rights, it was in her late 40s and early 50s that her political career became established. In 1948, she was hired into the prestigious position as the executive director of Harry Truman's reelection campaign, and she worked to connect the candidate to African American voters. In 1954, she was appointed to the New York City mayoral cabinet, becoming not only the first woman but also the first African American to hold the position. As the civil rights movement began to gather steam and national attention in the early 1960s, Anna became a respected leader, helping to organize the 1963 March on Washington for Jobs and Freedom. In 1966, she was one of the cofounders of the National Organization for Women. She continued to advocate for civil rights through lectures and books until her death in 1990 in Harlem, New York.

Debbie Millman is an author, an educator, a brand strategist, and the host and founder of the first and longest-running design podcast, *Design Matters*. As the former chief marketing officer at Sterling Brands, she worked with clients to develop some of the world's most widely recognized brand identities and merchandise. She is the editor in chief of *Print* magazine and the cofounder of the first graduate program in branding at New York City's School of Visual Arts. She is president emeritus of AIGA and one of only five women in 100 years to have held the position. It wasn't until her 40s that she began to realize and enact her full potential in her field. At age 54, Debbie continues to be a leader in the design world, both in discipline and in discourse. *Graphic Design USA* named her one of the most influential designers working today.

Lisa: Tell us about the early part of your career.

Debbie: When I was in my 20s, I had no idea what I wanted. I knew that I wanted a lot, but I had very little encouragement or guidance as I was growing up, so I felt really inhibited about what I was both qualified for and entitled to. I didn't feel that I was smart enough or capable enough or pretty enough or rich enough or anything enough to do much of anything. I mostly just fell into things and took almost whatever was offered, only because I was afraid that nothing else would come along. And so I would say the first ten years of my career in my 20s and into my 30s were experiments in rejection and failure, because I just kept trying to figure out what I was capable of and what I could do. It was a very tough, tumultuous ten years. I applied to a graduate program in journalism and I didn't get in, and I applied to Whitney's Independent Study

Program and I didn't get in, and so I just kept plowing along doing design.

When I was in my early 30s, quite by accident, while I was at a job at which I was very unhappy, I was contacted by a headhunter to work at a branding company. I was offered the opportunity to do sales, and while I didn't really fancy myself a salesperson, or consider the possibility of a career in sales, I thought it was an opportunity to get out of the company I was in. I would also have an opportunity to learn about the world of branding, which I was really fascinated by. So I did that and at this point I was 31 or so, and I found that I was really good at selling branding. I intrinsically understood it and the motivations for organizations that were looking to rebrand in the fast-moving consumer-goods category. So by accident, I learned that I was really good at something I didn't even know there was an opportunity to be good at.

I did that for two years and then the company was folded into another company, and it became very challenging politically. My boss quit and the creative director walked out one day, and it was really tumultuous. I called another headhunter and I asked her if she had anything that she could think of that I might be able to do. She thought I might do well at this little fledgling company she knew that had just come out of bankruptcy called Sterling. She hooked me up with the CEO, and we met and had a meal together. He told me about how he was trying to revive the agency, and I decided that I didn't have much to lose. That was in 1995. I was 33.

Lisa: At 54, you are a star in your field. We sometimes assume that people who are stars in their field have always been stars, but you and I both know that's not true.

Debbie: It's not. It took me ten years after college to find my career path. And from there I really worked as hard as I could to make an impact. I was managing new business, marketing, and public relations. I worked harder than I ever had before, and for a period of time, I gave up much of my outside-of-work creative projects like painting and drawing and writing that had always been so important to me.

Lisa: That hyperfocus really paid off: three short years after you started there, you became the president of the design division at Sterling. At that point, some would say you had reached a pinnacle of success, but while this was all happening for you, you actually felt there was something missing

from your life. Your career as we know it now hadn't even begun yet.

Debbie: I had been focusing on this one path at Sterling and I started to feel like all I was doing was commercial work—that I wasn't doing anything that was purely design, anything that was beautiful for its own sake.

I was trying really hard to get involved with AIGA and I'd felt a lot of rejection from them. Then in 2003 there was an article written about me in *Speak Up* by Armin Vit, which attempted to take down my whole career in branding. The article made fun of my work and trashed me and trashed the identities I had worked on—for companies like Burger King and Star Wars—and basically called me a corporate clown and a she-devil.

I was devastated. I was crushed by it. I was humiliated and embarrassed. I didn't know if people at Sterling would find out I was written about this way and if it would hurt the company. I ended up writing into the forum (it's still online to this day), to try and defend the kind of work that I was doing, and then the situation only got worse. I got torn down even further, but I tried my best to stay classy and not allow myself to be bullied, and also not to bully back. I stood my ground, and then a couple of weeks later, Armin wrote to me and apologized, not for thinking that my work was a pair of turds, as he put it, and which he told me he believed, but for the way in which I was bullied on the site.

I had never heard of blogs before that, and

I thought that there was something really interesting about the idea of conversing in real time with fellow designers, holding them accountable, debating ideas and having a discourse. I told him that, and then he wrote me back and asked if I wanted to write for the site. And I quickly agreed and started writing for *Speak Up* that same year, and everything after that sort of snowballed. I started writing, and one of my pieces even went viral in 2004.

Lisa: So you began writing about design. That must have felt great to the part of you that was looking for something beyond work at Sterling.

Debbie: Yes, and then very shortly after that I was cold-called by a fledgling Internet radio network that was looking for me to host a show, but I very quickly realized they weren't going to pay me. I actually had to pay them for the airtime, but at that point, as we've been discussing, I was really anxious to do something creative that wasn't about selling work to clients. It was about ideas and discourse, and so I took the idea of writing about design in real time to talking about design in real time. I did that for a hundred episodes starting in 2005 until 2009. I did about twenty-five shows a year, paid to do it the whole time, and got better and better at it. I had no aspiration before doing it to be a radio host. iTunes had just taken off and I thought, *Oh, let me put this up on iTunes*, and by default it became the first design podcast. There were no design podcasts because there was no such thing as a podcast, so all of that happened very organically.

And then in 2009, Bill Drenttel asked me if I'd be interested in bringing the show to the *Design Observer*, and we got a new professional recording set up. I really started to take it even more seriously.

Lisa: Then you got an important call that led to yet another amazing opportunity.

Debbie: The *Speak Up* team of writers, as sort of this band of misfits, went to the AIGA conference in Vancouver in 2003. While en route to the conference, I met Joyce Kay, who was then editor in chief of *Print* magazine, and I told her about *Speak Up*. She came to one of our parties, and she invited me to participate as a panelist in a sort of live, on-the-spot event that she was doing as part of the How Conference the following year in 2004. There I met art director, journalist, critic, author, and editor Steve Heller. I invited him out to lunch. I told him that I was interested in writing a book and shared my ideas. He said that he thought my ideas were terrible and to keep working and coming up with better ones. Four months later, out of the blue, he referred me to a publisher who had offered him a book deal that he passed on and suggested they call me instead, and that was how *How to Think Like a Graphic Designer*, my first book and my best seller, came to be. Steve also asked me to create a Masters of Branding program with him at the School of Visual Arts. And then Emily Oberman called me to be part of the New York board of AIGA, and I served on the board for two years; then I moved to the national board; then I was asked to be the president of the

entire organization. So every single thing that happened post-2003, I can trace back to that one forum on *Speak Up*. Every single thing.

Lisa: That is a perfect story of turning lemons into lemonade.

Debbie: It wasn't even turning lemons into lemonade. It was turning lemons into lemon meringue pie! I think anything worthwhile takes a long time and requires working through the rejection and criticism. It's almost impossible to have a career without ups and downs, and the more time you take to learn from your experience, the longer your career will last.

Lisa: In your late 30s and early 40s, all of these things outside of Sterling began happening, as a result of your perseverance and courage, that enriched and grew your career: writing, the podcast, your initial involvement with AIGA. You also took a class from design great Milton Glaser that inspired you to take all of those things and grow them with intention.

Debbie: Yes, that was in 2005. It was a summer intensive at the School of Visual Arts for midlevel designers and creative people who needed or wanted to reinvigorate their practice and their discipline. The class was all about declaring what you wanted for the next phase of your life. And so I came to the class really open and desirous of making this big leap to my next chapter. One of the last exercises in the class was to envision what you wanted your life to be like if you could do anything you wanted. I made this list of about twenty things I wanted that seemed really, really farfetched—big, fat dreams. And if I look at that list now (it's been eleven years and it was a five-year plan), at the end of five years, I would say 60 to 70 percent of it had come true; at ten years, I would say 80 percent had come true; and at this point, probably 90 percent. And they were big dreams—not like, *Oh, I wanna remodel my bathroom.* It was, *I want to rethink my whole life, I want to teach, I want to be part of AIGA in a significant way.* So I went from wanting to be involved in AIGA to running the national organization within four years. I wanted to teach, and by the end of my five years, I was running a graduate program.

Lisa: Many women talk about getting more confident as they age, but you argue that while confidence is important, courage is more important. Tell us about that.

Debbie: I think confidence comes from a repeated effort that continues to go well. So if you try something and you are successful at it, you feel that if you do it again you will be successful again. And that repeated success breeds confidence. I think it's actually more important to have courage, because you tend to be more afraid of doing things that you've never done before and through which you have no previous experience of success. Courage is more important than confidence because it forces you to try new things, to move outside what is comfortable.

Lisa: You also say that every year you age, your life gets better.

Debbie: I had such low self-esteem for the first thirty years of my life and didn't believe that I could have much of anything that I wanted. It was really, really important to me to try to fit in. At least if I had anything, it would be that I fit in. I'd think, *At least I have a community of friends I can depend on.* The older I've gotten and the more I've been able to depend on myself, I can see that I can take care of myself and be self sufficient. I began to be less fearful about being my real self. Along with becoming braver in my career, I also came out as a lesbian at 50 years old. I started to feel even more open to the possibilities of my life.

Lisa: What advice would you give to older women who might be feeling fearful or stuck and are considering pursuing a passion, coming out of the closet, or changing their life in some significant way?

Debbie: Because of the way I was brought up, I felt very afraid of ever putting myself in a situation where I was vulnerable. If you are coming from that place in your heart, it's very, very hard to do anything that requires confidence, courage, stamina, or persistence over the long haul. I think that if people want to do something they are afraid to do, it will likely stem from a place of not feeling capable.

And so my advice—and this is what I did—is to look at why you feel you can't rely on yourself. Why do you feel that you won't be able to do something you really want to do? What is the mindset that is creating that foundation of belief? And if you can work on that foundation of belief and why you feel that way, then from

there you will find profound momentum. We often edit what's possible for our lives before we even imagine what's possible. We start to censor before we even dream.

Lisa: You have entered the last half of your life, and you're thriving in a way that you didn't in the first half. So what's next for you? What gets you out of bed every day?

Debbie: The possibility that I can do anything. Once I faced having a finite amount of time left in my life, I began to think, *I want to do everything I possibly can.* Mostly I just don't want to live with as much fear. I want to continue to feel like I can approach anything with an open heart and an open mind, and try my best not to let my fears and my pettiness or my small-mindedness stand in the way.

PEOPLE MAY CALL
AT MIDLIFE "A CRISIS,"
AN UNRAVELING—
YOU FEEL A DESP
LIVE THE LIFE YOU
NOT THE ONE YOU
LIVE. THE UNRAVEL
WHEN YOU ARE CH
UNIVERSE TO LET
THINK YOU ARE
AND TO EMBRACE

WHAT HAPPENS

BUT IT'S NOT. IT'S

—A TIME WHEN

ERATE PULL TO

WANT TO LIVE,

RE "SUPPOSED" TO

NG IS A TIME

ALLENGED BY THE

GO OF WHO YOU

SUPPOSED TO BE

WHO YOU ARE.

BRENÉ BROWN

Grandma Moses had never so much as stepped inside an art museum when she first picked up a paintbrush at age 76, even though her painting style was eventually compared to those of Henri Rousseau and Bruegel the Elder. She went on to become one of the United States's most well-known artists, beloved for her primitive depictions of rural farm life.

Born Anna Mary Robertson in Greenwich, New York, in 1860, she received only limited schooling before leaving home at age 12 to keep house for a neighboring family. She worked as a domestic until her marriage to Thomas Salmon Moses at age 27. The couple eventually bought a farm and raised five children (another five died in infancy). After her husband's death in 1927, she continued to live on the farm, now managed by her son, and eased into retirement, taking up embroidery, as she had never been one to be idle.

By age 76, arthritis had begun to make embroidery painful, so she turned to painting, creating detailed landscapes of farm life drawn from her own memories. "Grandma" Moses, as she had come to be known, entered her work (along with her jams and jellies) in the county fair, and the paintings were displayed at the local drugstore, where they were noticed and purchased by an art collector named Louis Caldor. Caldor was able to interest galleries in her work, despite the fact that, at age 79, it seemed unlikely to many that she would continue to produce more new work. Four years after beginning to paint, she had her first one-woman show in 1940 at the age of 80.

Riding a wave of interest in self-taught artists at the time, her popularity grew as she worked prodigiously—spending five to six hours every day painting at an old kitchen table. Outfitted in her iconic gray topknot, high frilled collars, and wire-rimmed spectacles, she became a midcentury pop culture figure, appearing in magazines and on television, but never changing her pragmatic outlook and plainspoken manner. In her words, "If I hadn't started painting, I would have raised chickens." She continued to paint nearly every day until her death at age 101, creating more than fifteen hundred canvases.

Dara Torres is most known for her 2008 return to the Olympic Games. She was 41 years old at the time, the oldest swimmer to ever earn a position on the U.S. Olympic Swim Team, and she won medals in every event she swam: three silvers. This was no easy feat, but it was also the third comeback of her competitive swimming career. She'd done it twice before—first, after a two-year break prior to the '92 Olympic Games, and again in 2000, at the age of 33. She walked away with five medals that year, again, as the oldest swimmer on the team. Dara is the first and only athlete to swim for the United States in five Olympic Games. And she is one of only a few Olympians to earn medals in five different Games. She lowered her own American record in the 50-meter freestyle ten times, more than any other American—a record she broke at the age of 40, just sixteen months after giving birth to her first child. Since retiring, she's written two books, including *Age Is Just a Number: Achieve Your Dreams at Any Stage in Your Life*. She currently tours the country as a motivational speaker.

Lisa: During your swimming career, you won twelve Olympic medals, broke your own record ten times, and earned so many accolades for being "the first," "the oldest," or "the only" that it's hard to keep track of them. Looking back, how do you characterize your most significant accomplishment in swimming?

Dara: I don't think I have just one! If you'd have asked me that when I was younger, I'd probably have given you a medal or a race and say this was it, but now that I'm older and I look back, it's not really that. The journey it took to get there is what's memorable for me, and what I learned about myself and what it took to be the best that I could be. Also, trying to balance motherhood and going after my dreams and

goals has probably been the most rewarding journey leading into the 2008 Olympics.

Lisa: So, you famously had not one, but three comebacks. What in particular inspired you to come back and compete in the 2008 Olympic Games?

Dara: There are many similarities between each comeback, and I think the main thing is that I missed the sport. You are a part of something your whole life and you go away from it, and there's a part of you that just really misses it. I know that I personally missed the competition. I think even at my first comeback—I was going to be 25 back in '92—I was considered really old for swimming. And I said to myself, *All right, I'm older now, let's do it!* Each comeback had to do

with missing the sport, loving the sport, falling in love with it again after I was away from it for a while, and also just trying something that no one had done.

Lisa: Speaking of that, in both of those games, in particular in 2008, you were the oldest swimmer on the Olympic team at 41. What was that like for you, in terms of your relationships with the other swimmers?

Dara: It was different because I was the same age or older than the coaches and trainers. I wondered if I would be like the mother hen or an aunt or big sister. Where would I fit in? When you're on a team like that, there's such camaraderie that you see the differences with, say, turning on the radio in the van on the way to practice and they want hip-hop and I want classic rock, or the fact that I can't do nine workouts a week. I was doing five workouts a week, while they were doing so much, because my older body couldn't recover. As far as community and getting along, I don't think anyone treated me any differently. I thought, if anything, that I could help the younger ones if they had questions. It's a great feeling trying to be there for the kids who look so nervous, just trying to talk to them. Maybe they didn't have a good swim, or maybe they had a great swim—whatever the circumstances were—it was nice to know that I could be there for them if they needed me.

Lisa: Tell us about how your training and competing in your 40s was physically different than it was in your 20s and 30s.

Dara: When I first decided to come back, I was really just training for exercise because I was pregnant. I was getting sick, but I wanted to exercise. And I didn't want this to be an excuse, like, *Oh, I don't want to work out because I'm pregnant*, and so I realized, *Oh wait, I could go to a pool—there's a gutter there. If I get sick, I can just throw up in the gutter and keep going*. That's just what my mentality was—no inclination of ever competing-competing. I ended up swimming the day that I had my daughter.

One of my coaches asked me if I wanted to swim in a meet that was three weeks after I delivered, and I said, "Just let me find out from my doctor." My doctor said, "Okay, you can do it." So I swam it and that was it. Then I went to the Masters Championships because my boyfriend at the time and father of my daughter got back into swimming after a number of years off and wanted to go. So we went, and somehow I qualified for the Olympic Trials. I didn't mean to, but then people kept coming up to me at this Masters meet, saying, "We need a 40-year-old in the Olympics!" I was like, "Great! Who's going? Let's cheer them on." And they said, "You!"

Lisa: So you went for it.

Dara: Yes, and I was expecting to do what I did when I was training at 32 or 33 years old, which was to do everything the kids were doing, and I learned really fast that I couldn't do double workouts. There was no way my body could recover from that, and I couldn't do the stuff they were doing. I couldn't do the

yardage, and so mentally it wreaked havoc on my brain. I said to myself, *If I'm not doing as much as they're doing, or more than they're doing, then how am I going to compete at their level?* That was what my mentality used to be—that I should be doing more than what they were doing to be better.

Eventually, I had to accept that it wasn't about doing what they were doing. It was about doing what was best for me and my body. So that's where I had to change my thinking after many years of always doing "extra" to be the best. There were many times I was on my coach's couch crying, because I was exhausted and I couldn't move. I had to make sure that I had really good communication with my coach—that he understood if I was trying to get out of practice it was because I was really hurting.

Lisa: You wrote a bestseller, *Age Is Just a Number*, so you're sort of an expert on this. What advice would you give to women who are interested in tackling an athletic endeavor or wanting to go back to something that they used to be really good at?

Dara: I think the biggest thing is not to compare yourself to your younger self. You can't say, for example, *When I was 15, I could swim this time, and why can't I swim that time again?* And I think you just really have to listen to your body and not feel like you have to do what you did when you were younger. You have to set new goals for yourself.

Lisa: Since you retired in 2012, how has swimming remained part of your life? What does your swimming life look like now?

Dara: I go a couple of days a week just to stay in shape. I swim on the Harvard Masters team, and I remember the first day I swam, they were taking the stopwatch out, and I said, "Look, I'm done being timed. I'm done going fast." I just kind of go at my own speed. I'm doing this for exercise. And I think there's always someone who comes in the pool who just wants to race me, and I just put my fins on and go kind of easy. I am enjoying the calmness and the quietness of the water and not feeling like I always have to compete. I mean, every once in a while I have some guy next to me and I'm like, *All right, you want to race? I'll race you.*

Katherine Johnson had a passion for mathematics and an unflinching curiosity that led her doggedly through the racism and sexism of the mid-twentieth century to find her place later in life among the pioneers of American space exploration.

Katherine was born in 1918 in West Virginia. Her love for numbers and mathematics was evident from early childhood. She was anxious to attend school like her older siblings and soon surpassed them, moving on to high school at age 10 and college at age 15. At a time when most African Americans did not receive schooling past eighth grade, her achievements were astounding.

In college, she took every mathematics course available and went on to be the first African American woman at her graduate school. Job opportunities in mathematics for women were near nonexistent, so Katherine embarked on a teaching career and later married and became a stay-at-home mother to three girls. When her husband became ill with a brain tumor, she wanted to return to the workforce. A family member let her know that the National Advisory Committee for Aeronautics, the predecessor to NASA, was specifically looking for African American females to work as "human computers" (the women would complete the engineers' calculations) at Langley Memorial Aeronautical Laboratory, now Langley Research Center.

Within weeks of her hiring at Langley, Katherine's abilities and assertiveness led her out of the computer pool and into briefings with the engineers. Five years later, at age 40, she became the only nonwhite, non-male member of the Space Task Group, a committee focused on manned space missions. Between the ages of 40 to nearly 70, Katherine was an essential and integral part of NASA. Among her contributing calculations were the trajectory of the first American in space, the launch window for the Mercury mission, and the trajectory for the *Apollo 11* flight to the moon. She continues to be a role model for women and people of color in science, and in 2015, at age 97, she was awarded the Presidential Medal of Freedom by President Obama.

ARE YOU WITH ME?
by
Chrissy Loader

There are some things I honestly never thought I'd still be doing at this point in my life. For one, dating—or wearing a bikini; eating burritos for breakfast, lunch, and dinner (or wanting to); and going to rock shows. Of course, there are also things I imagine I should've done a helluva long time ago, but never quite got around to. I'm thinking taking LSD, writing that next great American novel, finding true love, procreation, and a three-way in a hotel room in Paris. (Actually, I'm not really the three-way sort of gal, but wouldn't that be funny?)

Truth be told, if I look back on my expectations versus the reality, my life has turned into this strange inversion. I got married in my 20s and a good deal of my time was spent viewing life from the sidelines . . . or at least the side of a stage, considering my husband at the time was in a band. But in college I had big dreams—all I wanted to do was be a writer, a performer, or a *something*. I wanted to see and do *everything*. Though when life played itself out, I played it safe. I found myself both literally and figuratively in the backseat with no real desire, or ability, to control where I was going. And though I don't see myself taking up recreational

hallucinogens anytime soon, the older I get, the more risks I find myself taking.

When I think of how this change took place, I can't help but mark time—and my hurdles—with the many rock shows I've experienced. It's been a series of tiny clubs, wayward openers, drink tickets, and bottomless beers that finally hit this mad pinnacle. Though there was Casey Kasem and an early dominance over the car radio, my real love for music started when I was 12 years old. That's when I saw my first show at the California State Fair, where I accidently stumbled on Romeo Void with my born-again Christian bestie. I could hear Debora Iyall's growl, *"Never—never say never!"* and it lured us past the Tilt-A-Whirl, a game of corn toss, and cotton candy stands lit in neon to find ourselves experiencing a legitimate live performance without the parents.

At 14, I saw the Thompson Twins at UC Davis. A year later, garbed in a velvet tuxedo, China flats, and white geisha makeup, I stood in front of Freeborn Hall reading a well-worn paperback version of *Edie: An American Biography* while waiting to see the Cure perform during

their *Head on the Door* tour. Backstage, somewhere between kissing Robert Smith on the cheek and chugging a bottle of Freixenet cava I'd "borrowed" from my parents, I unofficially met the teenage boy who would later become my husband—though we wouldn't officially meet for another five years.

At 16, I saw the Smiths on their *Queen Is Dead* tour, and then Camper Van Beethoven during their *Our Beloved Revolutionary Sweetheart* era, and REM on their *Green* tour. I mention these shows not so much to brag about my arguably discerning taste so much as to say that I thought I knew who the hell I was then, or at least what I liked. I thought the Smiths were the greatest band in the world, and someday I would actually pay back that Freixenet loan.

While studying English and American literature at Berkeley, and still dewy with possibility, I saw Buffalo Tom at Berkeley Square and looked around the room long enough to say to myself, *I will not hang out at this particular party too long. Someday I'll get rid of my record collection, my array of beer-stained band T-shirts, and I won't give a shit about keeping up with new music anymore. I'll do what generations before me have done—I'll stay home and listen to the oldies.*

But then senior year in college, I officially met my now ex-husband at a dive bar in Sacramento. He was studying urban planning while playing in a "band" he called Pavement. I was an English major and imagined I would graduate to become an artist, writer, or actor—okay,

maybe even a mime—and I'd travel the world madly, visiting places like India, Indonesia, Ireland . . . and Indiana.

We listened to Echo and the Bunnymen and the Sun City Girls on repeat, drank gin and tonics, and ate Blondie's pizza. I didn't know it at the time, but I can now unequivocally say that this was one of those chance experiences that changed the course of my life. That urban planner became my first boyfriend. And though I did complete a Eurail stint and wrote my fair share of (really) bad poetry at Café Intermezzo on Telegraph Avenue, a year after graduation I found myself selling ugly turquoise T-shirts at Pavement's first West Coast show in San Francisco. At that moment, even though I was standing on a chair at the back of the room, I felt like I was watching history in the making. I was cheering my boyfriend on, and I felt like I could support him and help hold it all together with pure will. And it came together. There was palpable electricity in the air. Something was *actually* happening. They sang, *"Everything's ending here,"* and it felt like something was just beginning.

I didn't apply to grad school or teach English in Japan or take a job at the alt weekly or even become a mime—at least for the moment. Instead, I spent the next ten years managing my boyfriend's band's finances and answering fan mail. When they played Lollapalooza, I'd fly out to places like Atlanta to pick up merch money, stuffing it in a FedEx envelope for the flight back to San Francisco, where we lived. I wrote letters to the World Wide Web to

reserve a website under the name "Pavement" and miraculously got a manila envelope in response. I also did a few things for myself—like taking the occasional film class or making lattes at a local café. But overall, I willingly traded my own dreams for the chance to ride along on someone else's.

It took too long to see I needed my own gig, but I did see this. And the summer before I went to grad school in Seattle, I found myself in another room, watching my then-husband in a different band. This time I was tour manager, driving a white van through the Midwest while my ex's post-Pavement solo act opened for Wilco. It was a tough period, and, in retrospect, I can see I had started to figure out who I was right as my ex was mourning the loss of his own identity.

The band played a show in Evanston, Illinois, where I was one of only two people in attendance. It was the kind of show that can break you, even if you're just watching. I wanted to hold up the band and hide behind the merch table. But this was something I couldn't hold together—not the band or my imaginary future. I had thought once Pavement was over, my "real" life could begin. But it became clear that there wasn't any such thing as a real life, only this.

A few months before we got divorced, around the same time I was graduating, two things happened. It came over me that I wanted my maiden name back. I'd never been particularly tied to my name, but I suddenly missed it.

Around the same time, my ex stopped listening to new music. "Everything sounds the same," he said. "I hate all the new bands." He started buying boxed sets of Springsteen and Petty and incessantly alphabetized his vast record collection. By turns, I started *really* listening to music. I read music reviews, took recommendations, and went to shows on my own.

After grad school, newly single and living on my own for the first time in my life, I taught creative writing at the University of Washington and wrote restaurant reviews for the *Stranger*. I eventually moved back to San Francisco and continued to discover my own interests. I realized I had my own inner compass that led me in directions I didn't even know existed.

Over the years, I've thrown crazy dinner parties like it was a sport and traveled to Vietnam, India, Cuba, and Africa. And regardless of whether anyone is actually paying attention, I've written articles and short stories and—more recently—made short films with friends.

Now, I'm 47 years old, and I still go to live shows. I say fuck it—why would I ever give this up? Maybe I'll grow gray and decrepit, but the truth is, I know now that there are no age limits when it comes to appreciating and creating art and music. There are no points in life when we need to give up the things we love.

I recently saw Dungen in the redwoods while surrounded by tree houses and wild Swedes with dancing babies. I saw Savages at the

Fillmore, Black Mountain at the Independent, and, based on a friend's recommendation, I've been listening to A Giant Dog on repeat. Even if I'm an old fart, I still like to dance.

The other night, I saw Cate Le Bon at the Chapel. I ran into friends I hadn't seen for a while, and the room was full. I stooped behind an impossibly tall guy, straining to see, and then there was this lovely surprise of her noodly guitar and that crazy magic was in the air. Something was happening—I knew! And my heart clinched and I felt the sting of tears welling up inside me. The music made me feel all my heartbreak, and the rise and fall of life's happiness and despair. I fell into her effervescent vocals, and they rang through me as she sang, "*Are you with me now? AhAhAhAh!*" I felt as much with her, and everything, as I ever have—maybe more.

Chrissy Loader is a lapsed academic, a freelance writer, a fledgling filmmaker, and the managing editor at the Presidio, an innovative national park near the Golden Gate Bridge. She lives in San Francisco and is at work on a full-length screenplay—a comedy about a ramshackle band touring the United States circa 1991

Marguerite Duras was 70 years old when she published her first bestseller, *The Lover*, and won the Prix Goncourt, France's highest literary honor. A survivor of a troubled childhood and a lifetime of alcoholism, she called on her own memories to create the novel for which she would be most well known.

Marguerite was born in Saigon, in what was then French Indochina, now Vietnam, in 1914, to French schoolteacher parents. Her father died just a few years later, leaving Marguerite, her two brothers, and her mother destitute. Her mother eventually cobbled together enough money to purchase a small farm, but Marguerite's childhood was marked by hardship, poverty, and family violence. As a young teen, she had a sexual relationship with an older wealthy Chinese man, an experience later fictionalized in *The Lover*. "Very early in my life it was too late," she wrote.

Marguerite left to attend the Sorbonne in France and eventually married and had a son. After studying political science and law, she became involved with the Communist Party and the French Resistance during World War II. She started writing novels, essays, and screenplays with intense focus in her late 30s. Her screenplay for *Hiroshima, Mon Amour* was nominated for an Oscar in 1959 when she was 45 years old.

Marguerite suffered from alcoholism throughout her adult life. "Every hour a glass of wine," she later shared. At age 68, she was forced to dry out when she was diagnosed with cirrhosis of the liver. It was immediately after this challenging period of recovery that Marguerite began to write *The Lover*. Despite a five-day coma, a tracheostomy, and other medical challenges, Marguerite continued to actively work and published several more novels before her death in 1996 at the age of 81.

Betty Reid Soskin is the oldest national park ranger in the United States. At 95 years old, she is stationed at the Rosie the Riveter World War II Home Front National Historical Park in Richmond, California, where she has worked for more than a decade. A California Bay Area resident since the age of 6, Betty first worked as a clerk for a Jim Crow boilermakers union during World War II. She then opened Reid's Records in Berkeley in the mid-1940s, endured racism and death threats as a young African American housewife in an all-white suburb, became a political activist in the 1960s, was a well-known songwriter in the civil rights movement, and served as a field representative for the California State Assembly—all of this prior to employment with the National Park Service. Betty is a respected voice for the historical preservation of the African American wartime experience. In 2010, California College of the Arts awarded her an honorary doctorate. In 2015, she accepted a commemorative presidential coin from President Obama, and, in 2016, she received the Silver Service Medallion from the National World War II Museum.

Lisa: You began your career as a national park ranger about ten years ago, when you were 85. How did you learn about the position and what was it that made you want to take the job?

Betty: I was serving as a field representative on the California State Assembly when the park was being created in the district I represented. I attended the planning meetings and subsequently became a sort of informal volunteer consultant to the National Park Service in that role, and then that morphed into me becoming a term park ranger.

Lisa: Did you have to go through special training to become an official park ranger?

Betty: Absolutely not [laughs]. I am working way beyond my capacity. I'm doing things I was never trained to do!

Lisa: What keeps you going to work every day?

Betty: My first eight decades were spent collecting dots, and now I'm connecting dots. I'm in what I assume to be my final decade, and so everything I ever learned I'm using now. I'm still having first-time experiences at 95. I feel like an evolving person in an evolving nation in an evolving universe.

Lisa: And what kinds of things do you do when you go to work every day?

Betty: My work consists mostly of outreach. I do three to five talks a week in my theater. I show an orientation film, which was named for this park. Every national park has an orientation film and ours is about a 15-minute story, which deals with the history of Richmond itself. I do a commentary at the end, which makes for about an hour's program. Because the history is so multifaceted—there are so many stories within the story of the home front—it can't be encapsulated in 15 minutes in the film. And the feminist stories are in conflict. So I flesh that out and also layer back in the complexity of the times, which includes the African American story.

Lisa: You're celebrated as a voice for the historic preservation of the wartime experience of African Americans. How do your own experience and the experience of your family inform what you discuss with park visitors?

Betty: The park had been inspired by the Rosie the Riveter story, and because I am a woman of color, that story did not sit well with me because I considered it a white woman's story. The women in my family had been working outside their homes since slavery. What I do is watch the film that was created for us, which is, incidentally, a very fine film. And then when the film ends, I add to that story by adding a woman of color's history, which is my own.

My story varies from the norm because, unlike the white women who were emancipated by

the Rosie the Riveter role into nontraditional labor, I was a child who'd grown up on the West Coast outside of the hostile South. This meant that in 1942 (I was in my early 20s) at the opening of the war and the great migration of black and white culture from the South, the entire system of Southern segregation came with them. So unlike the white women who were released into their "Rosie roles," at that time I discovered my limitations. I was working in a Jim Crow union hall because unions were not yet racially integrated. And so my life story turns out to be something of a revelation to people who didn't live it.

Lisa: What is it like to share your story on a stage twice a week with people who would otherwise not ever hear the perspective of a woman of color of your age?

Betty: I find that people are open to hearing the story. Part of what I talk about is admitting that the film is a disappointment to me because my reality was not included. My story represents who we were as a nation in 1942. What I'm doing is admitting that this was where we started, and then owning where we started leads me to how far we've come. And comparing 1942 with today (and not from outside the circle, but from inside the circle) is a novel picture for my audiences. I was a clerk in a Union Hall in 1942, and then fifteen years ago I became a field representative under the California State Assembly. Which means that this is not a case of personal achievement. It is a case of how much social change occurred in this nation over those intervening years. And so that's how I approach the story, putting that

history in the past, but bringing people into the present and the future.

Lisa: What is your message about the future to the people you talk to?

Betty: That by recounting who we were in 1942, including the limitations that we were living under (segregation and all the rest of it), that Henry Kaiser and his workforce of mostly sharecroppers completed 747 ships in three years and eight months right here in his four parks in the city of Richmond. And by doing so, he literally outproduced the enemy and helped to turn the course of the war around and bring peace.

We did that under a severely flawed social system, and my telling of my story outlines that severely flawed social system. But what I do then is say that now our children and grandchildren are confronted with a new threat—that of global warming and rising sea levels and climate change—and they're going to have to match and exceed that great mobilization of the 1940s, and that mobilization could be seen as the equal of the Great Wall of China or the building of the pyramids. That this was Franklin Delano Roosevelt's great "Arsenal of Democracy." And I explain that they're going to have to match and exceed that same mobilization in order to save the planet, and they're going to do it under a still flawed social system. Because the nature of democracy is that it never will stay fixed—it wasn't intended to. Every generation has to re-create democracy, and the 39 percent turnout in the last election does not bode well for our ability to sustain

our governance. The system of national parks allows us to revisit almost any era in our history, the heroic places and the contemplative places, and the scenic wonders, and the shameful places and the painful places, in order to own that history and process it so that we can move together into a more compassionate future. And that's really what the purpose of the parks is for me personally. And helping to bring that into being, I consider that to be almost like a holy grail—that I get to live my last decade helping to bring the awareness of that to the public, and I think that's a gift.

Lisa: Your mother and grandmother lived to be over 100, is that true?

Betty: Yes, my grandmother lived to be 102, meaning that I was 27 years old, married, and a mother by the time she died. And I knew her as the matriarch of my family. And my mother lived to be 101. The three of us bridge everything from Dred Scott and the Civil War through Orlando.

Lisa: Obviously, you have good genes. But is there also a way you live your life that might account for your longevity and enthusiasm for living?

Betty: I have lived my complete life in a total state of surprise. I am not a planner and I'm still having first experiences. I'm still wondering what I'm going to be when I grow up.

Lisa: Recently on your blog, you were reflecting on your "new normal"—your sort of late-in-life career as a park ranger and

the growing public attention. What do you make of all this fuss about you at this stage of your life?

Betty: It's not comfortable at times, partly because it's almost unbelievable. It's kind of unreal. I have lost anonymity, and I think that was always some of my protection. I don't know how to feel about it. I think had it come earlier in life, it might have been easier to deal with. It's hard to take seriously at this point. It's hard to account for the fact that celebrity becomes self-generating after a while. That it grows on its own and, as such, it's suspect. In some ways I think had it come twenty years ago, I might have been able to deal with it better. But now it's very hard for me to take seriously.

Lisa: In a recent Tavis Smiley interview on PBS, you said, "I don't live in the past or future; my life is now." I'm curious: what does "living in the now" mean to you?

Betty: I've spent my entire life being contemporary to the times in which I'm living. I am working now as a 95-year-old in a world that's much, much younger than I am. There are no elderly rangers. The only people who are a reminder of my stage in life are when tour buses drive up with people from retirement homes, and the people file in and I have to remind myself that these are my contemporaries.

Lisa: And I am sure most of them are younger than you!

Betty: Absolutely. Many of them are! I'm so in the present, and I've always been. And I don't

know how others live their lives, or how the way I live compares to the way other older people live. I don't resent aging. I've never hidden my age. I've never done anything to stall the aging process. I really do see that this is my last decade and that feels right to me.

Lisa: We know that because of genetics, science, and technology, people are going to live longer, healthier lives and are going to stay in the workforce longer and contribute in significant ways. For those women who are younger than you are and might find themselves in your shoes in some ways, healthy and able to give back, but are unsure whether they can or should, what do you say to those women?

Betty: I think that because I am physically fit, because I'm not Botoxed and I've not given in to any kind of plastic surgery, because I'm still working five days a week, and because I'm still fully engaged in life—that I am perhaps offering an alternative to a system that involves the adoration of youth culture. Maybe that's why I'm catching the attention of the boomers who are now moving into the possibility that you are describing. That living longer and opting out of the workforce at 65 will no longer be practical. Maybe we're going to start looking at aging differently, and maybe I'm a forerunner. It's certainly not that I'm exceptional. I don't believe that's true. It's that life is still opening up for me. Over the past several months, I've been seated at a laptop in our conference room doing a session with high school kids in an auditorium in Eugene, Oregon, on Skype. I'm doing it again with the Philadelphia

I am PERHAPS OFFERING an alternative to a system that involves the adoration of youth culture.

BETTY REID SOSKIN

Annual Flower Show, serving on a panel with two other rangers across the entire country. I mean, these are crazy things! I never know what the days are going to hold, or what the weeks are going to hold. I can't wait to see.

I think there's a whole wave of people approaching their 70s, and they're wondering whether or not they should fold their tents, and I think maybe the fact that I'm still active is opening some doors for some possibilities that people may not have dreamed possible.

I also think aging is contagious, even for me. I was at a training at the Grand Canyon some time ago and the young receptionist at the National Park Service Visitor Center invited me to go down the mountain to Sedona. And I was curious about the vortexes and experiencing that. I remember driving down through the canyon in a top-down convertible, and I'm in my blue jeans and my T-shirt, and I was really excited. We approached the vortex and there were some elderly people coming down the first plateau, and I overheard the woman saying, "It's okay to go up there, but when you're coming down, you have to sit down on your bottom and slide down because you'll get really dizzy." And immediately after hearing this, I could not go any farther, because I became old. I never did get to the vortex. I think if I hadn't heard that conversation, I'd have been bouncing all the way to the top.

ACKNOWLEDGMENTS

I am enormously grateful to the huge number of people who made this book come to life. In fact, so many people contributed to it that in some ways this book doesn't even feel like it's entirely mine. First and foremost, I would like to thank my studio manager and assistant, Kristin Wilson. As with everything she touches, Kristin embraced this project with unadulterated enthusiasm. She did countless hours of research, editing, writing, permissions gathering, people wrangling, and scheduling—all with fantastic grace and organization. Thank you, Kristin, for everything you are and everything you do to support my creative endeavors!

Huge and heartfelt thanks also to my beloved editor at Chronicle Books, Bridget Watson Payne—along with *everyone* at Chronicle Books—for continuing to believe in me and my ideas! Thank you to my literary agent, Stefanie Von Borstel, for her continued support and kindness. Thank you to my sister, Stephanie Congdon Barnes, who wrote several of the profiles and offered endless hours of supportive listening as I toiled over the making of this book. A gigantic collective thank-you to all of the interviewees and essayists, who each gave not only time and energy to this book but also inspiring stories of perseverance and joy. Last but not least, thank you to my wife, Clay Lauren Walsh, for your unending devotion to me and to everything I pursue. Your love gives me wings.

BIBLIOGRAPHY

"About Beatrice Wood." Beatrice Wood Center for the Arts. www.beatricewood.com/biography.html.

"About Keiko." Keiko Fukuda Judo Foundation. keikofukudajudofoundation.org/index.php/about-keiko.

Adler, Laure. *Marguerite Duras: A Life*. Chicago: University of Chicago Press, 1998.

"Anna Arnold Hedgeman Was a Force for Civil Rights." African American Registry. www.aaregistry.org/historic_events/view/anna-hedgeman-was-force-civil-rights.

"Anna Arnold Hedgeman (1899–1990)." BlackPast.org, www.blackpast.org/aah/hedgeman-anna-arnold-1899-1990.

Cook, Joan. "Anna Hedgeman Is Dead at 90; Aide to Mayor Wagner in 1950s." *The New York Times*, January 26, 1990. www.nytimes.com/1990/01/26/obituaries/anna-hedgeman-is-dead-at-90-aide-to-mayor-wagner-in-1950-s.html.

"Eva Zeisel." Design Within Reach. www.dwr.com/designer-eva-zeisel?lang=en_US.

Eve, Debra. "The Flowering of Mary Delany's Ingenious Mind." LaterBloomer.com. www.laterbloomer.com/mary-granville-delany.

Fitch, Noel Riley. *Appetite for Life: The Biography of Julia Child*. New York: Anchor, 2010.

Fitzpatrick, Tommye. "Vera Wang Says Keep Your Feet on the Ground and Don't Get Ahead of Yourself." *Business of Fashion*, April 30, 2013. www.businessoffashion.com/articles/first-person/first-person-vera-wang.

Garas, Leslie. "The Life and Loves of Marguerite Duras." *The New York Times Magazine*, October 20, 1991. www.nytimes.com/1991/10/20/magazine/the-life-and-loves-of-marguerite-duras.html?pagewanted=all.

"Grandma Moses Is Dead at 101." *New York Times Obituary*, December 14, 1961. www.nytimes.com/learning/general/onthisday/bday/0907.html.

Hamilton, William. "Eva Zeisel, Ceramic Artist and Designer, Dies at 105." *The New York Times*, December 30, 2011. www.nytimes.com/2011/12/31/arts/design/eva-zeisel-ceramic-artist-and-designer-dies-at-105.html?_r=1.

"Helen Gurley Brown." Biography.com. www.biography.com/people/helen-gurley-brown-20929503#synopsis.

"Helen Gurley Brown: American Writer." *Encyclopedia Britannica*. www.britannica.com/biography/Helen -Gurley-Brown.

Julia! America's Favorite Chef: About Julia Child. DVD. Directed by Marilyn Mellowes. New York: Thirteen/ WNET, 2005. www.pbs.org/wnet/americanmasters /julia-child-about-julia-child/555.

Kallir, Jane, et al. *Grandma Moses in the 21st Century*. New Haven, CT: Yale University Press, 2001.

"Katherine G. Johnson." Makers.com. www.makers.com /katherine-g-johnson.

"Katherine Johnson: A Lifetime of Stem." Nasa.gov. www .nasa.gov/audience/foreducators/a-lifetime-of-stem.html.

"Katherine Johnson: The Girl Who Loved to Count." Nasa.gov. www.nasa.gov/feature katherine-johnson -the-girl-who-loved-to-count.

Lang, Olivia. "Every hour a glass of wine'—the female writers who drank." *The Guardian*, June 13, 2014. www.theguardian .com/books/2014/jun/13/alcoholic-female-women-writers -marguerite-duras-jean-rhys.

Larocca, Amy. "Vera Wang's Second Honeymoon." *New York* magazine. nymag.com/nymetro/news/people/features/15541/ index1.html.

"Laura Ingalls Biography." *Encyclopedia of World Biography*. www.notablebiographies.com/We-Z/Wilder-Laura -Ingalls.html.

"Laura Ingalls Wilder." Biography.com. www.biography.com /people/laura-ingalls-wilder-9531246.

"Louise Bourgeois: French-American Sculptor." The Art Story. www.theartstory.org/artist-bourgeois-louise.htm.

"Louise Bourgeois." MOMA.org. www.moma.org/explore /collection/lb/about/biography.

Lowry, Dave. "The Life of Keiko Fukuda, Last Surviving Student of Judo Founder Jigoro Kano." *Black Belt Magazine*, February 12, 2013. www.blackbeltmag.com/daily/traditional -martial-arts-training/judo-traditional-martial-arts/the-life-of -keiko-fukuda-last-surviving-student-of-judo-founder-jigoro -kano.

Marguerite Duras—Worn Out with Desire to Write. Video. Directed by Alan Benson and Daniel Wiles. 1985. New York: Films Media Group, 1985.

May, Meredith. "Keiko Fukuda – judo master – doc in 2012." *SF Gate*, July 25, 2011. www.sfgate.com/entertainment /article/Keiko-Fukuda-judo-master-doc-in-2012-2353236.php.

McCulloch, Susan. "A Shy Woman of Wild Colours." *The Sydney Morning Herald*, April 8, 2006. www.smh.com.au /news/obituaries/a-shy-woman-of-wild-colours/2006/04 /07/1143916714321.html.

Miller, Jo. "Sister Madonna Buder. 'Iron Nun,' Is Oldest Woman to Ever Finish an Ironman Triathlon." *The Huffington Post*, July 4, 2014. www.huffingtonpost.com/2014/07/04 /iron-nun-triathlon_n_5558429.html.

"Minnie Pwerle." Aboriginal Art Directory. gallery .aboriginalartdirectory.com/aboriginal-art/minnie-pwerle /awelye-atnwengerrp-13.php.

Peacock, Molly. *The Paper Garden: An Artist Begins Her Life's Work at 72*. Toronto: McClelland & Stewart, 2010.

Reichl, Ruth. "Julia Child's Recipe for a Thoroughly Modern Marriage." *Smithsonian Magazine*, June 2012. www.smithsonianmag.com/history/julia-childs-recipe -for-a-thoroughly-modern-marriage 86160745.

Rosenberg, Karen. "A Shower of Tiny Petals in a Marriage of Art and Botany." *The New York Times*, October 22, 2009. www.nytimes.com/2009/10/23/arts/design/23delany.html.

Russeth, Andrew. "Don't Be Intimidated About Anything: Carmen Herrera at 100." *Art News*, June 5, 2015. www.artnews.com/2015/06/05/dont-be-intimidated-about -anything-carmen-herrera-at-100.

Simmons-Duffin, Selena. "'Cosmo' Editor Helen Gurley Brown Dies at 90." *NPR*. August 13, 2012. www.npr.org /2012/08/13/158710834/cosmo-editor-helen-gurley -brown-dies-at-90.

"Sister Madonna Buder, 'The Iron Nun.'" TriathlonInspires. com. www.triathloninspires.com/mbuderstory.html.

Smith, Robert. "Beatrice Wood, 105, Potter and Mama of Dada, Is Dead." *The New York Times*, March 14, 1998.

Sontag, Deborah. "At 94, She's the Hot New Thing in Paint- ing." *The New York Times*, December 19, 2009. www.nytimes .com/2009/12/20/arts/design/20herrera.html.

"The Spider's Web." *The New Yorker*, February 4, 2002. www.newyorker.com/magazine/2002/02/04/the-spiders-web.

"Vera Wang." Biography.com. www.biography.com/people /vera-wang-9542398.

Whitney, A. K. "The Black Female Mathematicians Who Sent Astronauts to Space." Mental Floss. mentalfloss.com /article/71576/black-female-mathematicians-who-sent -astronauts-space.

"Who Is Eva Zeisel?" EvaZeisel.org. www.evazeisel.org /who_is_eva_zeisel.html.

Wood, Beatrice. *I Shock Myself: The Autobiography of Beatrice Wood.* San Francisco: Chronicle Books, 2006.

Yardley, William. "Keiko Fukuda, a Trailblazer in Judo, Dies at 99." *The New York Times,* February 6, 2013. www.nytimes .com/2013/02/17/sports/keiko-fukuda-99-a-trailblazer-in -judo-is-dead.html?_r=0.

CREDITS

Page 7: "Age has given me what I was looking for my entire life—it has given me me. It has provided time and experience and failures and triumphs and time-tested friends who have helped me step into the shape that was waiting for me. I fit into me now. I have an organic life, finally, not necessarily the one people imagined for me, or tried to get me to have. I have the life I longed for. I have become the woman I hardly dared imagine I would be." —Anne Lamott. Excerpt(s) from PLAN B: FURTHER THOUGHTS ON FAITH by Anne Lamott, copyright © 2005 by Anne Lamott. Used by permission of Riverhead, an imprint of Penguin Publishing Group, a division of Penguin Random House LLC. All rights reserved.

Page 14: Painting of Beatrice Wood based on a photograph by Tony Cunha. Copyright © Beatrice Wood Center for the Arts.

Page 23: Painting of Vera Wang based on a photograph by Christopher Peterson.

Page 28: Painting of Louise Bourgeois based on a photograph by Chris Felver.

Page 40: Painting of Keiko Fukuda based on photography by Arik-Quang V. Dao from San Jose Buddhist Judo Club.

Pages 60–61: "We are getting older, and we are getting wiser, and we are getting freer. And when you get the wisdom and the truth, then you get the freedom and you get power, and then look out. Look out." From "A Conversation with Melissa Etheridge" by Marianne Schnall on Feminist.com. Used by permission of the author.

Page 75: "The flowers don't know they're late bloomers. They're right in season." —Debra Eve. Excerpt from the article "What's Wrong with the Term 'Later Bloomer'?" Laterbloomer.com. Used by permission of the author.

Page 82: Painting of Sister Madonna Buder based on a photograph by J. Craig Sweat.

Page 94: Painting of Carmen Herrera based on a photograph by Adriana Lopez Sanfeliu.

Page 114: Painting of Eva Zeisel based on a photograph by Talisman Brolin.

Pages 128–129: "People may call what happens at midlife 'a crisis,' but it's not. It's an unraveling—a time when you feel a desperate pull to live the life you want to live, not the one you're 'supposed' to live. The unraveling is a time when you are challenged by the universe to let go of who you think you are supposed to be and to embrace who you are." —Brené Brown. Excerpt from *The Gifts of Imperfection: Let Go of Who You Think You're Supposed to Be and Embrace Who You Are* by Brené Brown. Used by permission of the author.